textile motifs of
INDIA

TEXTILMOTIVE AUS INDIEN • MOTIVOS TEXTILES DE LA INDIA
MOTIFS TEXTILES INDIENS • MOTIVI TESSILI DELL'INDIA • MOTIVOS TÊXTEIS DA ÍNDIA
印度的纺织品设计 • **РИСУНКИ И УКРАШЕНИЯ ТЕКСТИЛЯ ИНДИИ** • インドの織物モチーフ

THE PEPIN PRESS | AGILE RABBIT EDITIONS

The Pepin Press | Agile Rabbit Editions publishes a wide range of books on art, design, architecture, applied art, fashion and popular culture.

For a complete list of available titles, please visit our website at: www.pepinpress.com

The following is a selection of the titles available from our website or at your local bookseller.

Weaving Patterns
Lace
Embroidery
Ikat Patterns
Batik Patterns
Indian Textile Prints
Tapestry

Floral Patterns
Wallpaper Designs
Watercolour Patterns
Marbled Paper Designs
Historical & Curious Maps

Chinese Patterns
Japanese Patterns
Indian Textile Prints
Turkish Designs
Persian Designs
Islamic Designs
Islamic Designs from Egypt
Arabian Geometric Patterns

Traditional Dutch Tile Designs
Barcelona Tile Designs
Tile Designs from Portugal
Havana Tile Designs

Mediæval Patterns
Gothic Patterns
Renaissance Patterns
Baroque Patterns
Rococo Patterns

Art Nouveau Designs
Jugendstil
Art Deco Designs
Fancy Designs 1920
Patterns of the 1930s

Images of the Universe
Female Body Parts
Fruit
Vegetables
Flowers

Fancy Alphabets
Signs & Symbols
1000 Decorated Initials

How To Fold
Structural Package Designs
Special Packaging
Take One

Web Design Index
Web Design Index by Content

Figure Drawing for Fashion Design
Wrap & Drape Fashion
Fashion Design 1800-1940
Art Deco Fashion

Ethnic Jewellery
Crown Jewellery

COLOPHON

Copyright all illustrations and text
© 2008 Pepin van Roojen
All rights reserved

The Pepin Press | Agile Rabbit Editions
P.O. Box 10349
1001 EH Amsterdam, The Netherlands

Tel +31 20 420 20 21
Fax +31 20 420 11 52
mail@pepinpress.com
www.pepinpress.com

Editor: Pepin van Roojen
Picture restoration: Kirsten Quast
Layout: Kirsten Quast & Pepin van Roojen

ISBN 978 90 5768 075 5

10 9 8 7 6 5 4 3 2 1
2012 11 10 09 08 07

Manufactured in Singapore

CONTENTS

Free CD-Rom inside the back cover

3

TEXTILE MOTIFS OF INDIA

This book contains a collection of some of the most beautiful design elements and patterns found in Indian textiles; all digitized and restored to make them suitable for present-day use.

BOOK AND CD-ROM

The images in this book can be used as a graphic resource and for inspiration. All the illustrations are stored in jpg format on the enclosed CD-ROM and are ready to use for printed media and web page design. The pictures can also be used to produce postcards, either on paper or digitally, or to decorate your letters, flyers, T-shirts, etc. They can be imported directly from the CD into most software programs. Some programs will allow you to access the images directly; in others, you will first have to create a document, and then import the images. Please consult your software manual for instructions.

The names of the files on the CD-ROM correspond with the page numbers in this book. The CD-ROM comes free with this book, but is not for sale separately. The files on Pepin Press/Agile Rabbit CD-ROMs are sufficiently large for most applications. However, larger and/or vectorised files are available and can be ordered from The Pepin Press/Agile Rabbit Editions.

IMAGE RIGHTS

For non-professional applications, single images can be used free of charge. The images cannot be used for any type of commercial or otherwise professional application - including all types of printed or digital publications - without prior permission from The Pepin Press/Agile Rabbit Editions. Our permissions policy is very reasonable and fees charged, if any, tend to be minimal.

For inquiries about permissions and fees, please contact:
mail@pepinpress.com
Fax +31 20 4201152

TEXTILMOTIVE AUS INDIEN

Dieses Buch enthält eine Sammlung der schönsten Designelemente und Muster indischer Textilkunst. Sämtliche Motive wurden mit größter Sorgfalt restauriert und digitalisiert, sodass sie sich auch für heutige Anwendungen eignen.

BUCH UND CD-ROM

Dieses Buch enthält Bilder, die als Ausgangsmaterial für grafische Zwecke oder als Inspirationsquelle genutzt werden können. Alle Abbildungen sind auf der beiliegenden CD-ROM im JPEG-Format gespeichert und lassen sich direkt zum Drucken oder zur Gestaltung von Webseiten einsetzen. Sie können die Designs aber auch als Motive für Postkarten (auf Karton bzw. in digitaler Form) oder als Ornament für Ihre Briefe, Broschüren, T-Shirts usw. verwenden. Die Bilder lassen sich direkt von der CD in die meisten Softwareprogramme übernehmen. Bei einigen Programmen lassen sich die Grafiken direkt einladen, bei anderen müssen Sie zuerst ein Dokument anlegen und können dann die jeweilige Abbildung importieren. Genauere Hinweise dazu finden Sie im Handbuch Ihrer Software.

Die Namen der Bilddateien auf der CD-ROM entsprechen den Seitenzahlen in diesem Buch. Die CD-ROM wird kostenlos mit dem Buch geliefert und ist nicht separat verkäuflich. Alle Bilddateien auf den CD-ROMs von The Pepin Press/Agile Rabbit wurden so groß dimensioniert, dass sie für die meisten Applikationen ausreichen; zusätzlich können jedoch größere Dateien und/oder Vektorgrafiken bei The Pepin Press/Agile Rabbit Editions bestellt werden.

BILDRECHTE

Einzelbilder dürfen für nicht-professionelle Anwendungen kostenlos genutzt werden; dagegen muss für die Nutzung der Bilder in kommerziellen oder sonstigen professionellen Anwendungen (einschließlich aller Arten von gedruckten oder digitalen Medien) unbedingt die vorherige Genehmigung von The Pepin Press/Agile Rabbit Editions eingeholt werden. Allerdings handhaben wir die Erteilung solcher Genehmigungen meistens recht großzügig und erheben – wenn überhaupt – nur geringe Gebühren.

Für Fragen zu Genehmigungen und Preisen wenden Sie sich bitte an:
mail@pepinpress.com
Fax +31 20 4201152

MOTIFS TEXTILES INDIENS

Cet ouvrage comprend une collection de certains des plus beaux éléments de style et motifs qu'on retrouve dans les tissus indiens, tous restaurés et numérisés pour s'adapter à un usage actuel.

LIVRE ET CD-ROM

Les images contenues dans ce livre peuvent servir de ressources graphiques ou de source d'inspiration. Toutes les illustrations sont stockées au format JPG sur le CD-ROM ci-joint et sont prêtes à l'emploi sur tout support imprimé ou pour la conception de site Web. Elles peuvent également être employées pour créer des cartes postales, en format papier ou numérique, ou pour décorer vos lettres, prospectus, T-shirts, etc. Ces images peuvent être importées directement du CD dans la plupart des logiciels. Certaines applications vous permettent d'accéder directement aux images, tandis que d'autres requièrent la création préalable d'un document pour pouvoir les importer. Veuillez vous référer au manuel de votre logiciel pour savoir comment procéder.

Le nom des fichiers du CD-ROM correspond aux numéros de page de cet ouvrage. Le CD-ROM est fourni gratuitement avec ce livre mais ne peut être vendu séparément. Les fichiers des CD-ROM de The Pepin Press/Agile Rabbit sont d'une taille suffisamment grande pour la plupart des applications. Cependant, des fichiers plus grands et/ou vectorisés sont disponibles et peuvent être commandés auprès des éditions The Pepin Press/Agile Rabbit.

DROITS D'AUTEUR

Des images seules peuvent être utilisées gratuitement à des fins non professionnelles. Les images ne peuvent pas être employées à des fins commerciales ou professionnelles (y compris pour tout type de publication sur support numérique ou imprimé) sans l'autorisation préalable expresse des éditions The Pepin Press/Agile Rabbit. Notre politique d'autorisation d'auteur est très raisonnable et le montant des droits, le cas échéant, est généralement minime.

Pour en savoir plus sur les autorisations et les droits d'auteur, veuillez contacter :
mail@pepinpress.com
Fax +31 20 4201152

MOTIVOS TEXTILES DE LA INDIA

Este libro contiene una colección de algunos de los diseños y motivos más hermosos empleados en tejidos procedentes de la India, todos ellos debidamente restaurados y digitalizados para adecuarlos a los usos actuales.

LIBRO Y CD-ROM

Este libro contiene imágenes que pueden servir como material gráfico o simplemente como inspiración. Todas las ilustraciones están incluidas en el CD-ROM adjunto en formato jpg y pueden utilizarse en medios impresos y diseño de páginas web. Las imágenes también pueden emplearse para crear postales, ya sea en papel o digitales, o para decorar sus cartas, folletos, camisetas, etc. Pueden importarse directamente desde el CD a diferentes tipos de programas. Algunas aplicaciones informáticas le permitirán acceder a las imágenes directamente, mientras que otras le obligarán a crear primero un documento y luego importarlas. Consulte el manual de software pertinente para obtener instrucciones al respecto.

Los nombres de los archivos contenidos en el CD-ROM se corresponden con los números de página del libro. El CD-ROM se suministra de forma gratuita con el libro. Queda prohibida su venta por separado. Los archivos incluidos en los discos CD-ROM tienen una resolución suficiente para su uso con la mayoría de aplicaciones. Sin embargo, si lo precisa, puede encargar archivos con mayor definición y/o vectorizados a The Pepin Press/Agile Rabbit Editions.

DERECHOS SOBRE LAS IMÁGENES

Para aplicaciones no profesionales, pueden emplearse imágenes sueltas sin coste alguno. Estas imágenes no pueden utilizarse para fines comerciales o profesionales (incluido cualquier tipo de publicación impresa o digital) sin la autorización previa de The Pepin Press/Agile Rabbit Editions. Nuestra política de permisos es razonable y las tarifas impuestas tienden a ser mínimas.

Para solicitar información sobre autorizaciones y tarifas, póngase en contacto con:
mail@pepinpress.com
Fax +31 20 4201152

MOTIVI TESSILI DELL'INDIA

Questo libro contiene una raccolta di alcuni tra i più bei motivi e disegni dei prodotti tessili indiani. Gli elementi decorativi sono stati sottoposti a opera di digitalizzazione e restauro, ai fini di un adattamento agli usi odierni.

LIBRO E CD-ROM

Le immagini contenute in questo libro possono essere utilizzate come risorsa grafica e prese a ispirazione. Nel CD-ROM accluso sono presenti tutte le illustrazioni in formato JPG, pronte per la stampa su qualsiasi tipo di supporto e per il web design. Le immagini possono anche essere utilizzate per produrre delle cartoline, sia su stampa che in digitale, o per decorare lettere, volantini, magliette, eccetera. Si possono importare direttamente dal CD e utilizzare con la maggior parte dei programmi informatici. Alcuni di questi vi permetteranno l'accesso diretto alle immagini; con altri, dovrete prima creare un documento e poi importare le immagini. Per ulteriori informazioni vi preghiamo di consultare il manuale del vostro software.

I nomi dei file sul CD-ROM corrispondono ai numeri di pagina del libro. Il CD-ROM viene fornito gratis con il libro, ma non è vendibile separatamente. Le dimensioni dei file sui CD-ROM della Pepin Press/Agile Rabbit sono adatte alla maggior parte delle applicazioni. In ogni caso, sono disponibili file più grandi o vettoriali che possono essere ordinati alla Pepin Press/Agile Rabbit Editions.

DIRITTI DI IMMAGINE

Le singole immagini possono essere utilizzate gratuitamente a fini non professionali. Non possono però essere utilizzate per nessun tipo di applicazione commerciale o professionale (compresi tutti i tipi di pubblicazioni stampate e digitali) senza la previa autorizzazione della Pepin Press/Agile Rabbit Editions. Gestiamo le autorizzazioni in maniera estremamente ragionevole e le tariffe addizionali applicate, qualora ricorrano, sono minime.

Per ulteriori informazioni riguardo alle autorizzazioni e alle tariffe, vi preghiamo di contattarci ai seguenti recapiti:
mail@pepinpress.com
Fax +31 20 4201152

MOTIVOS TÊXTEIS DA ÍNDIA

Este livro apresenta uma colectânea de alguns dos mais belos elementos de desenho e padrões dos têxteis indianos, todos eles digitalizados e restaurados para corresponderem às exigências das aplicações modernas.

LIVRO E CD-ROM

As imagens neste livro podem ser usadas como recurso gráfico e fonte de inspiração. Todas as ilustrações estão guardadas em formato jpg no CD-ROM incluído e prontas a serem usadas em suportes de impressão e design de páginas web. As imagens também podem ser usadas para produzir postais, tanto em papel como digitalmente, ou para decorar cartas, brochuras, T-shirts e outros artigos. Podem ser importadas directamente do CD para a maioria dos programas de software. Alguns programas permitem aceder às imagens directamente, enquanto que noutros terá de primeiro criar um documento para poder importar as imagens. Consulte o manual do software para obter instruções.

Os nomes dos ficheiros no CD-ROM correspondem aos números de páginas no livro. O CD-ROM é oferecido gratuitamente com o livro, mas não pode ser vendido em separado. A dimensão dos ficheiros nos CD-ROMs da Pepin Press/Agile Rabbit é suficiente para a maioria das aplicações. Contudo, estão disponíveis ficheiros maiores e/ou vectorizados, que podem ser encomendados à Pepin Press/Agile Rabbit Editions.

DIREITOS DAS IMAGENS

Podem ser usadas imagens individuais gratuitamente no caso de utilizações não profissionais. As imagens não podem ser usadas para qualquer tipo de utilização comercial ou profissional, incluindo todos os tipos de publicações digitais ou impressas, sem autorização prévia da Pepin Press/Agile Rabbit Editions. A nossa política de autorizações é muito razoável e as tarifas cobradas, caso isso se aplique, tendem a ser bastante reduzidas.

Para esclarecimentos sobre autorizações e tarifas, queira contactar:
mail@pepinpress.com
Fax +31 20 4201152

インドの織物モチーフ

本書にはインド織物に採用されている優美なデザイン要素およびパターンが収録されています。イメージは、さまざまな用途でご使用いただけるようデジタル化されています。

本書及びCD-ROM

本書のイメージは、グラフィック・デザインの参考にしたり、インスピレーションを得るための材料としてご使用ください。すべてのイラストはjpgフォーマットで作成されており、印刷媒体やウェブデザインでご利用いただけます。イメージは、絵はがき、レター、チラシ、Tシャツなどの作成にも利用できます。ほとんどのソフトウエア・プログラムへ、CD-ROMから直接インポートが可能です。直接イメージにアクセスできない場合には、まずファイルを作成することで、ご使用になりたいイメージを簡単にインポートできます。インポートの方法などの詳細については、ソフトウエアのマニュアルをご参照ください。

CD-ROMの各ファイル名は、本書のページ番号に対応しています。このCD-ROMは本書の附録であり、CD-ROMのみの販売はいたしておりません。Pepin Press/Agile RabbitのCD-ROM収録のファイルは、ほとんどのアプリケーションに対応できるサイズです。より大きなサイズのファイル、あるいはベクトル化されたファイルをご希望の方は、The Pepin Press/Agile Rabbit Editions宛てにご連絡ください。

イメージの著作権

イメージを非営利目的で使用する場合は、1画像のみ無料でご使用いただけます。印刷媒体、デジタル媒体を含む、業務や営利目的でのご使用の場合は、事前にThe Pepin Press/Agile Rabbit Editionsから許可を得ることが必要です。著作権料が必要となる場合でも最小限の料金でご提供させていただきます。

使用許可と著作権料については下記にお問い合わせください。
mail@pepinpress.com
ファックス: +31 20 4201152

印度的纺织品设计

本书收集了印度纺织品中部份最美丽的设计元素和图案，全部经过数字化处理及修复，以迎合现今的需求。

书及 CD-ROM

本书中的图像可用作图形资源，亦可用来启发创作灵感。书中的所有配图均以JPG格式存储在所附的CD-ROM中，随时可用于刊物媒体及网页设计上。图像亦可用于制作纸质或数字化的明信片，又或是用来装饰阁下的信件、宣传单张及T恤等。这些图像可以直接从CD输入到大多数软件程式中。有些程式可以直接连接到图像；有些则要求阁下先创设一个文件，然后才输入图像。欲知详情，请参阅阁下的软件指南中的说明。

CD-ROM中的档案名称是跟书中的页码相对应的。CD-ROM是随本书附送，并不作单独出售。The Pepin Press / Agile Rabbit 出版的 CD-ROM 所载有的档案均相当庞大，足以应付大多数的应用。不过，本社亦提供较大型及／或矢量格式化的档案，请到 The Pepin Press / Agile Rabbit Editions 选购。

图像的版权

在非专业的用途上，单个图像可供免费使用。在未经 The Pepin Press / Agile Rabbit Editions 出版社事先许可的情况下，图像不能用于任何类型的商业或其他专业用途，当中包括所有类型的打印或数字化的刊物。本社订有一套合理的许可政策。若有收费的需要，所涉及的金额亦通常是甚低的。

有关许可及收费的查询，请联系我们：
电邮： mail@pepinpress.com
传真： +31 20 4201152

РИСУНКИ И УКРАШЕНИЯ ТЕКСТИЛЯ ИНДИИ

В этой книге содержится коллекция некоторых из наиболее интересных элементов и узоров индийского текстиля. Все они представлены в оцифрованном виде и подготовлены для использования в современных условиях.

КНИГА И КОМПАКТ-ДИСК

Изображения, представленные в этой книге, можно использовать как графический ресурс и источник вдохновения. Все иллюстрации хранятся на прилагаемом компакт-диске в формате jpg и готовы к печати и использования в дизайне веб-страниц. Кроме того, рисунки можно использовать при изготовлении открыток, как на бумаге, так и цифровых, а также для украшения писем, рекламных материалов, футболок и т.д. Их можно непосредственно импортировать в большинство программ. В одних программах можно получить прямой доступ к изображениям, в других придется сначала создать документ, а затем уже импортировать изображения. Конкретные рекомендации см. в руководствах по программному обеспечению.

Имена файлов на компакт-диске соответствуют номерам страниц этой книги. Компакт-диск прилагается к этой книге бесплатно, но отдельно он не продается. Файлы на компакт-дисках Pepin Press/Agile Rabbit достаточно велики для большинства приложений. Однако в Pepin Press/Agile Rabbit Editions можно заказать и файлы большего объема или файлы векторизованных изображений.

АВТОРСКИЕ ПРАВА НА ИЗОБРАЖЕНИЯ

В применениях непрофессионального характера отдельные изображения можно использовать бесплатно. Изображения нельзя использовать в любых видах коммерческих или других профессиональных приложений – включая все виды печатной и цифровой публикации – без предварительного разрешения Pepin Press/Agile Rabbit Editions. Наша политика выдачи разрешений достаточно обоснованна и расценки оплаты, если таковая вообще потребуется, близки к минимальным.

С запросами по поводу получения разрешений и оплате обращайтесь:
mail@pepinpress.com
Факс +31 20 4201152

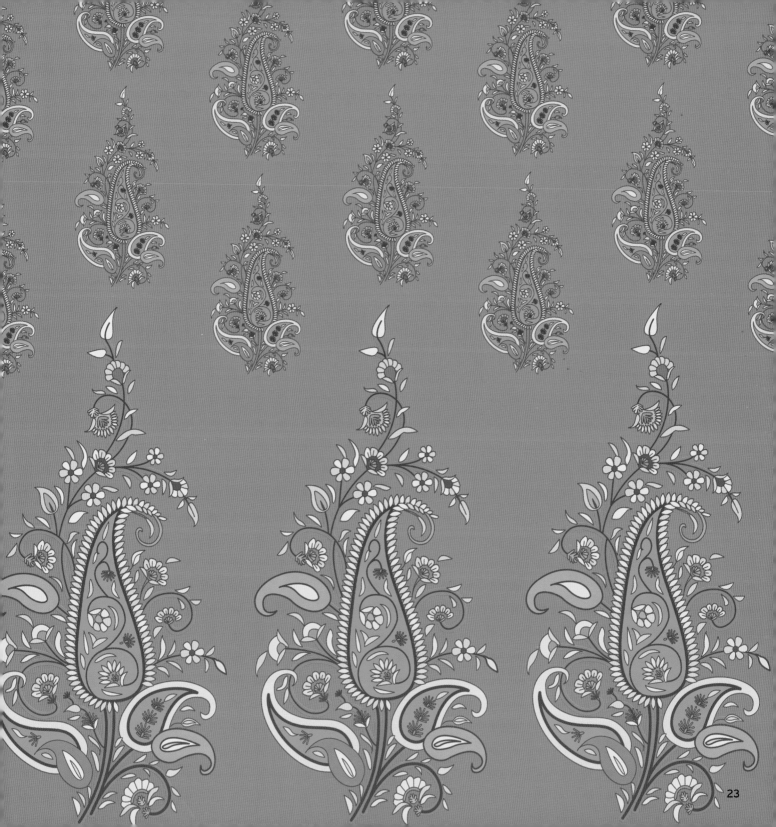

23

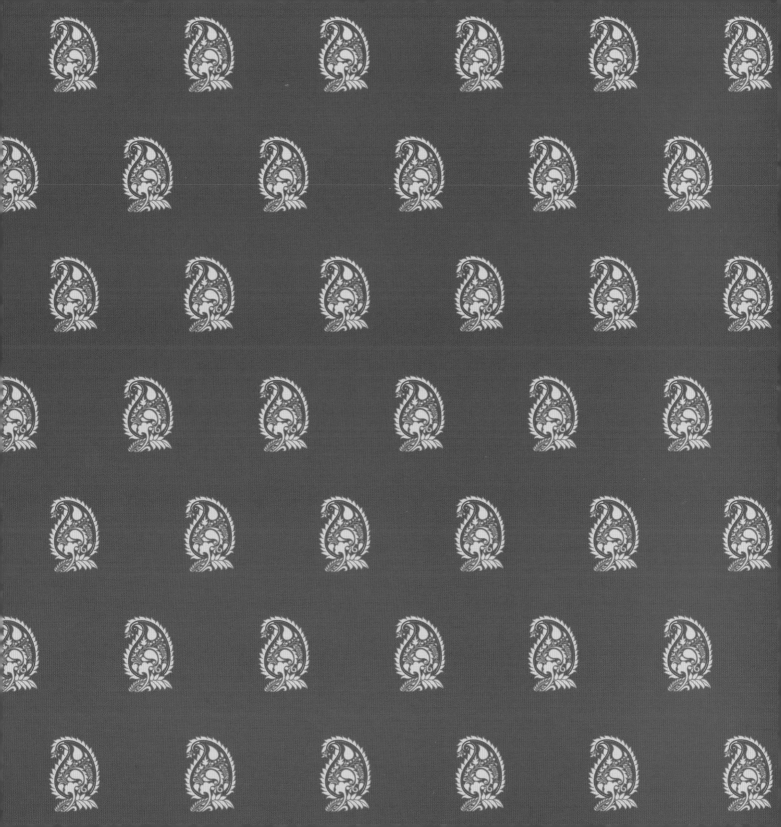

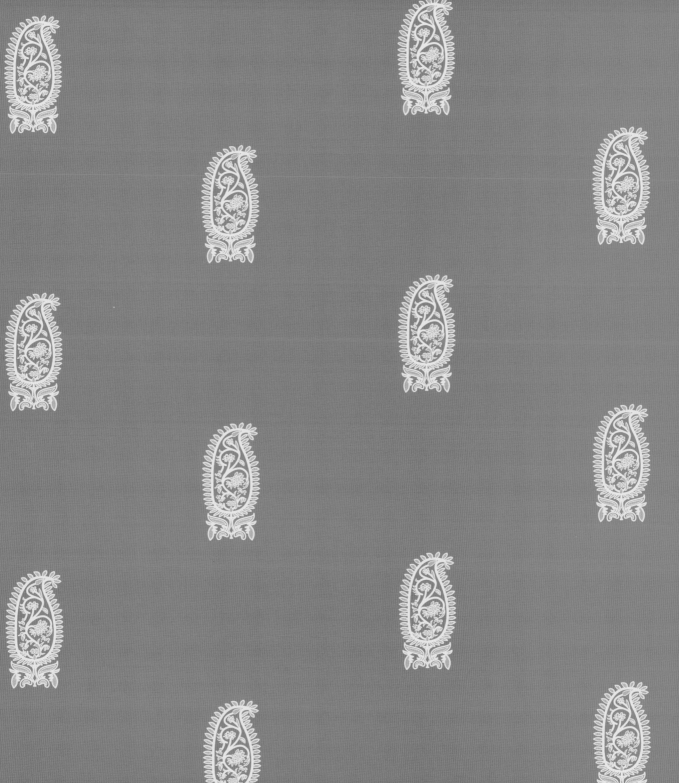

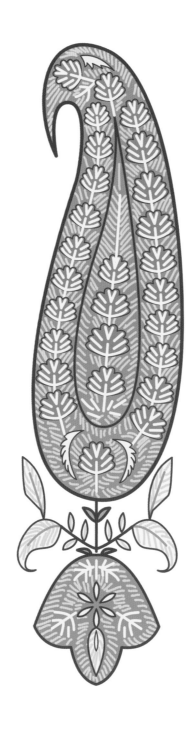

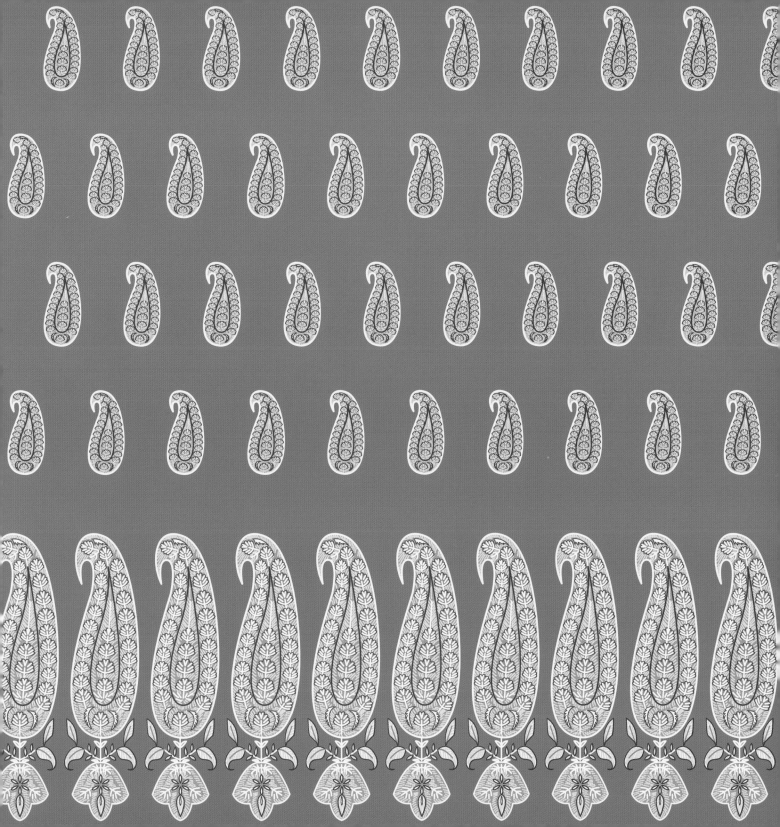

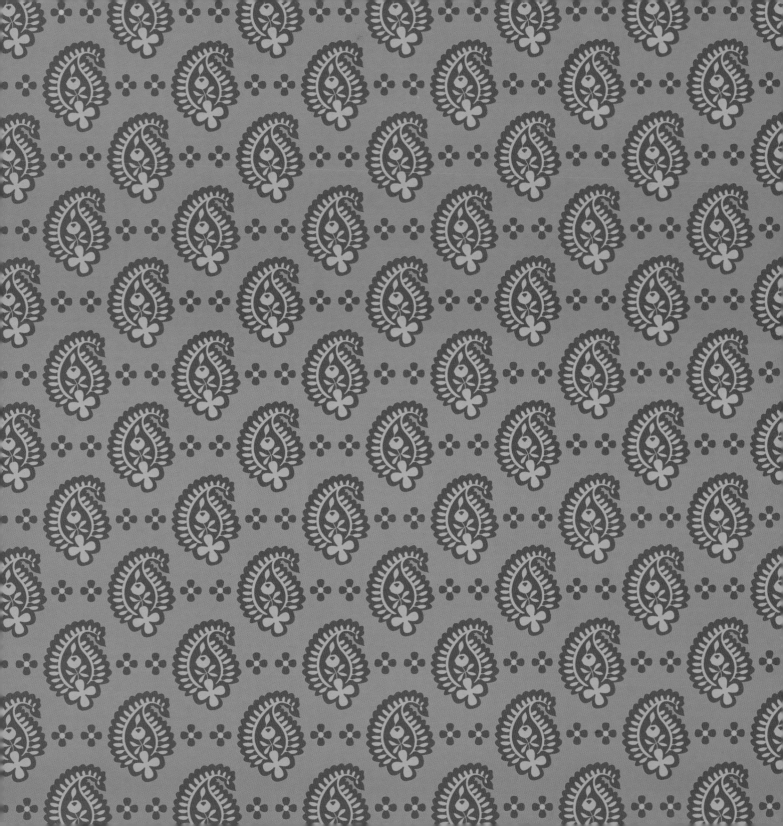

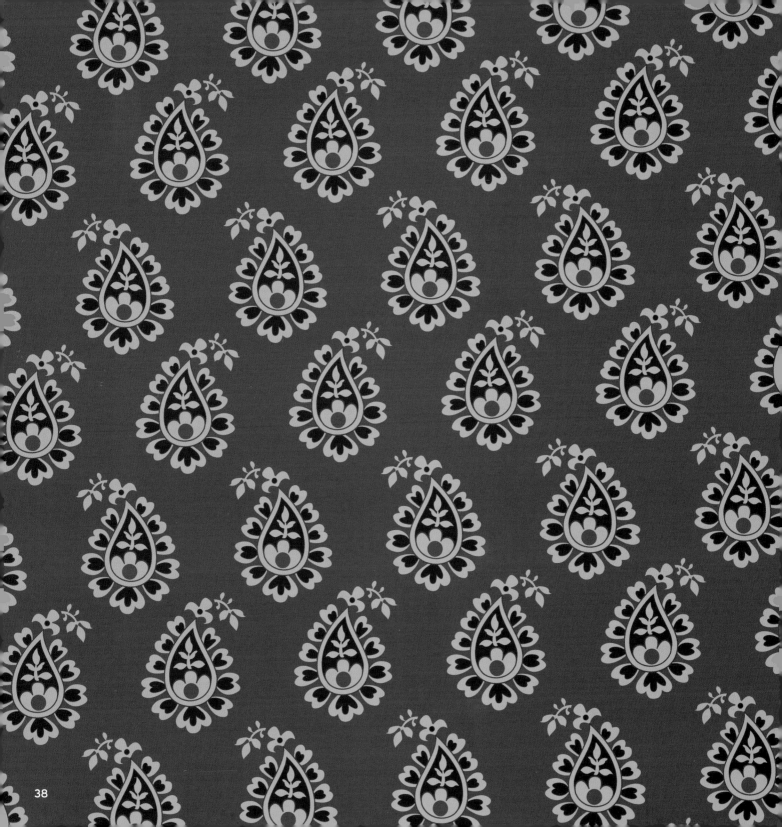

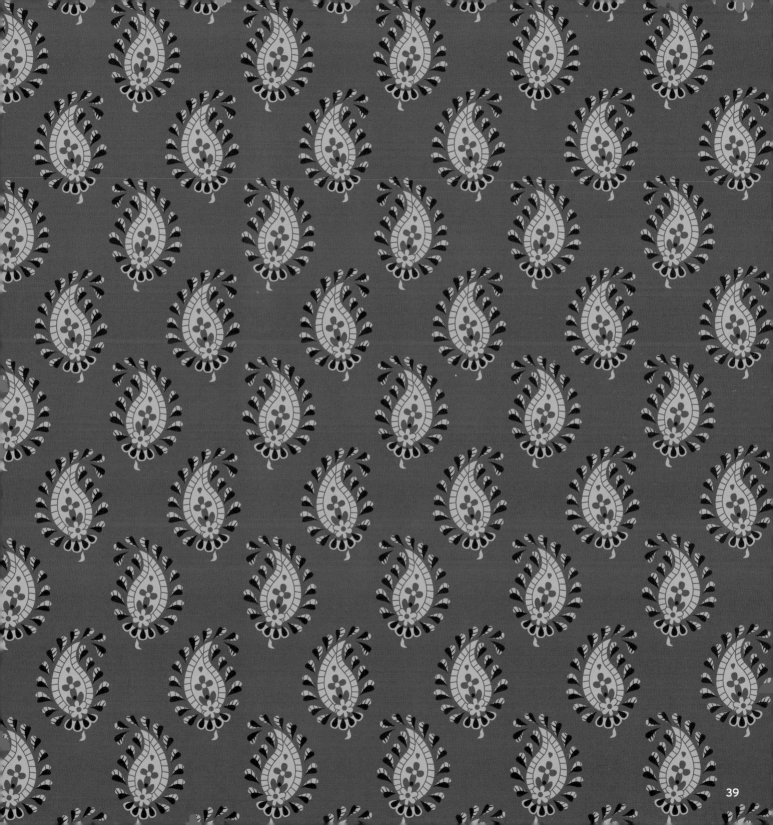

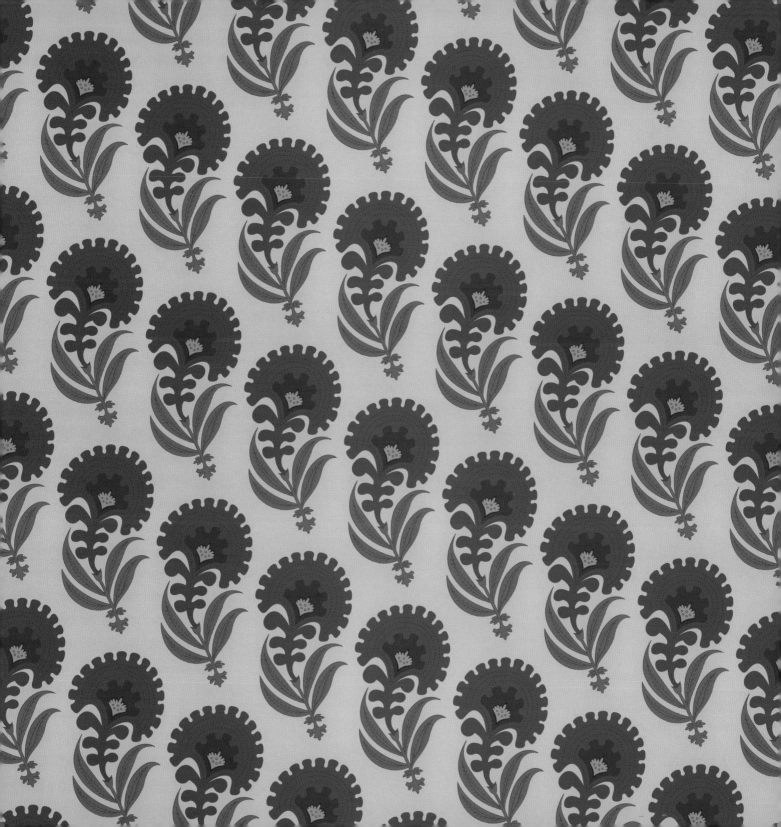

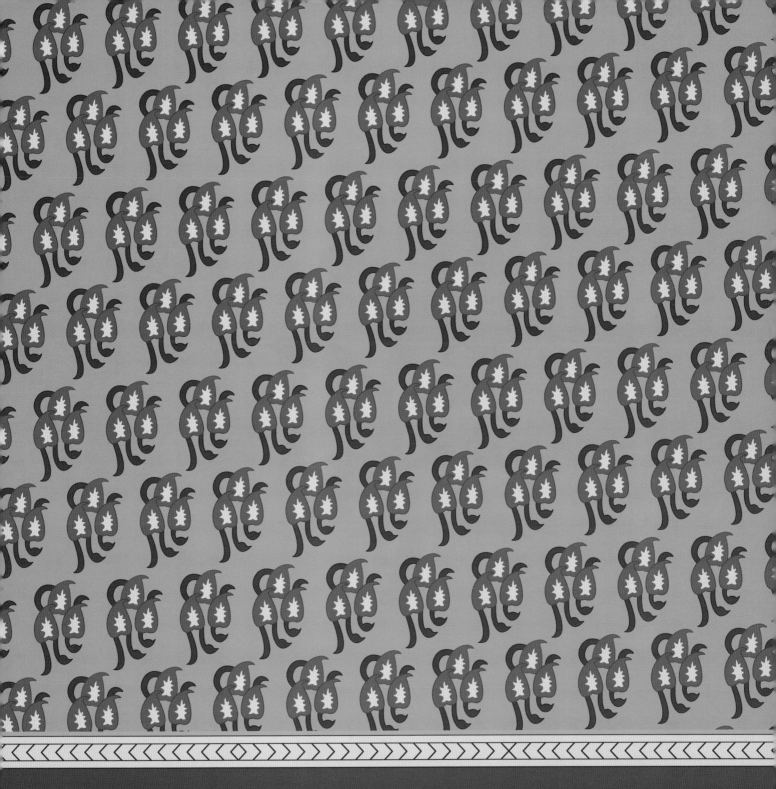

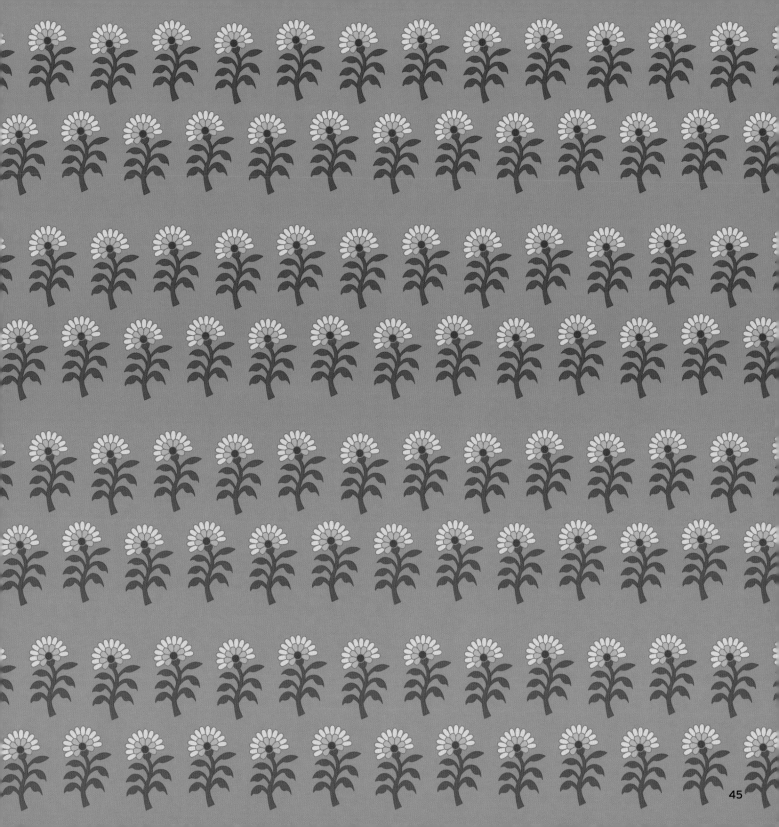

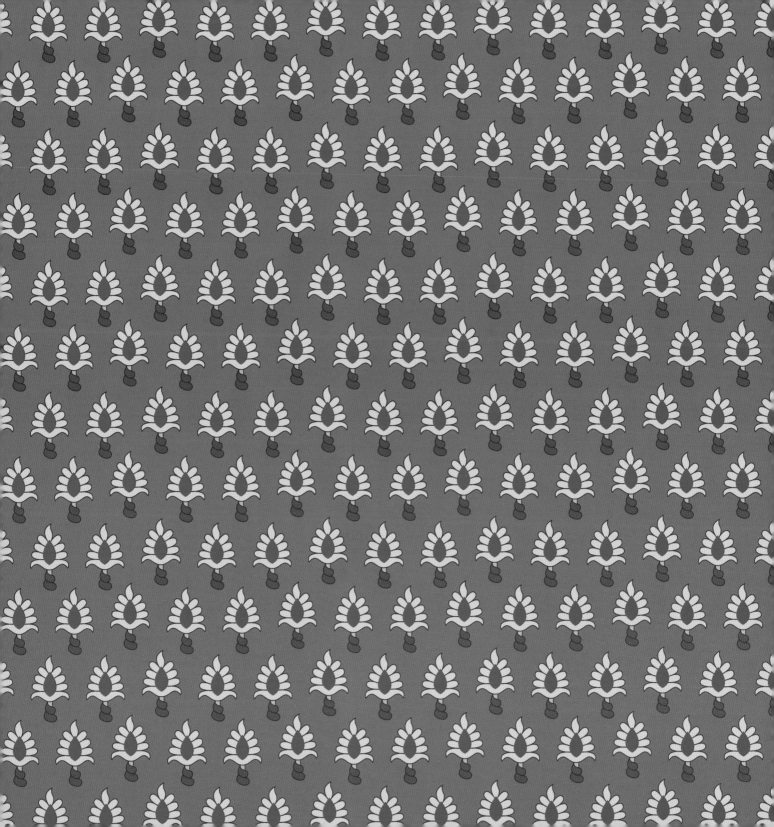

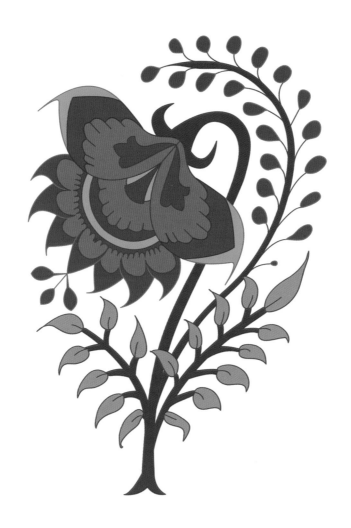

53

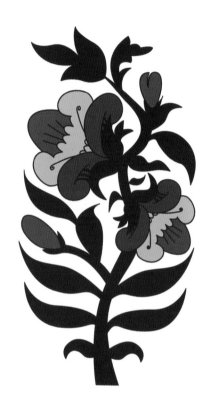 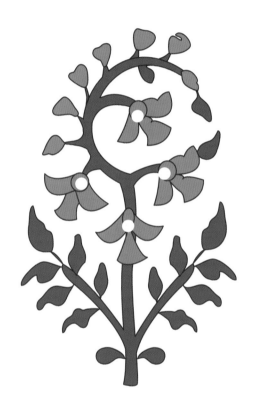

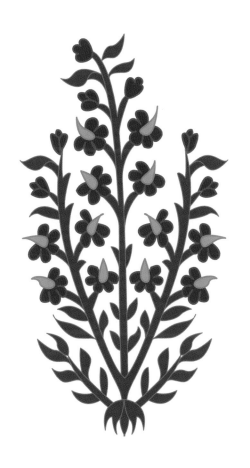
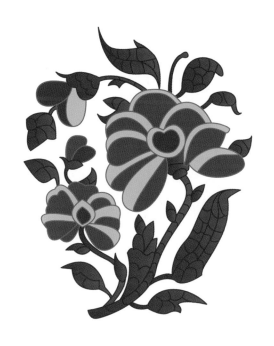

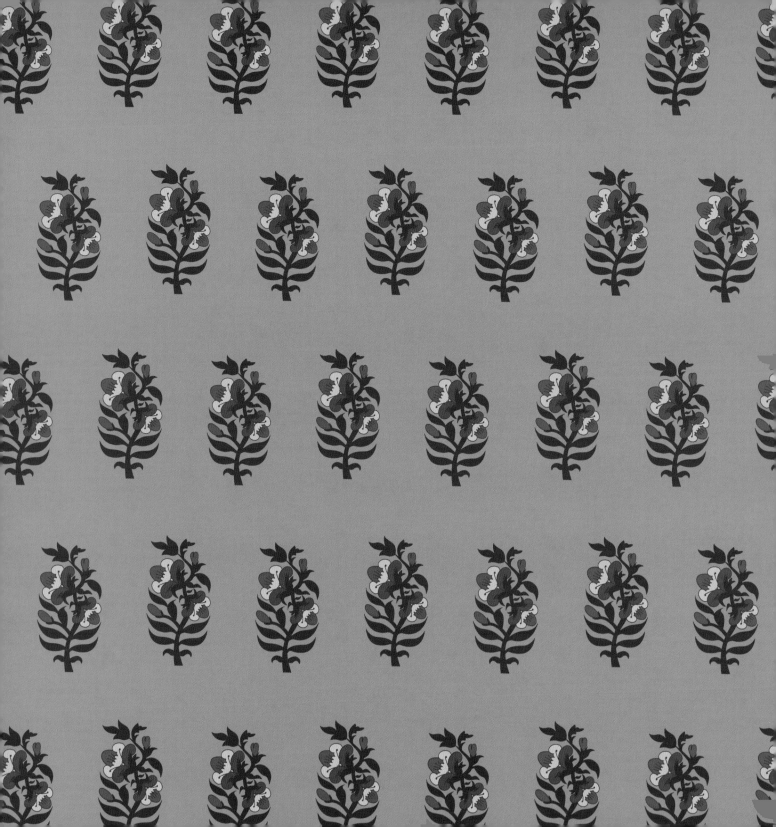

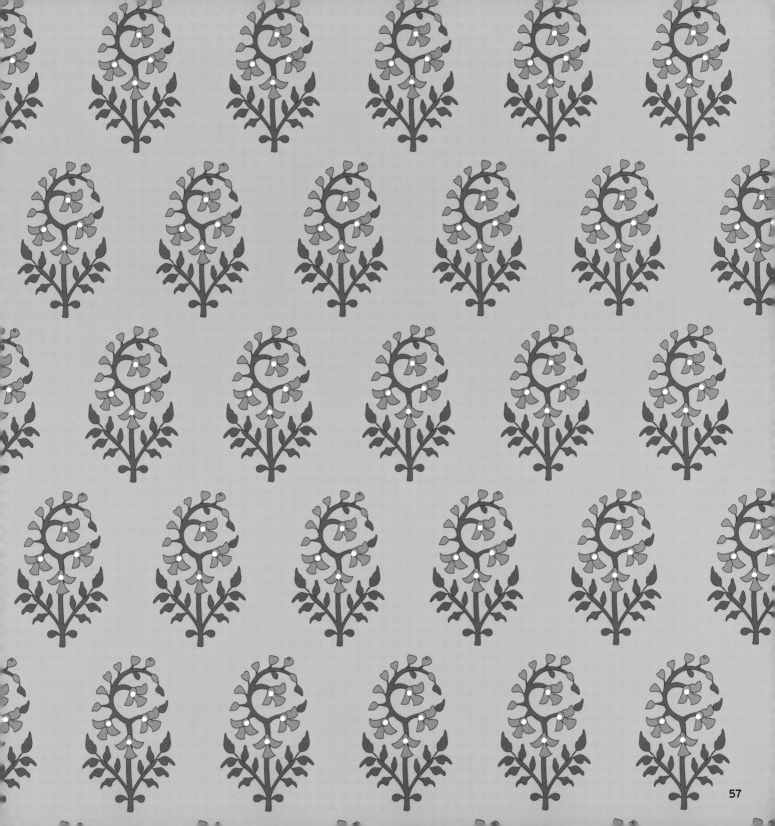

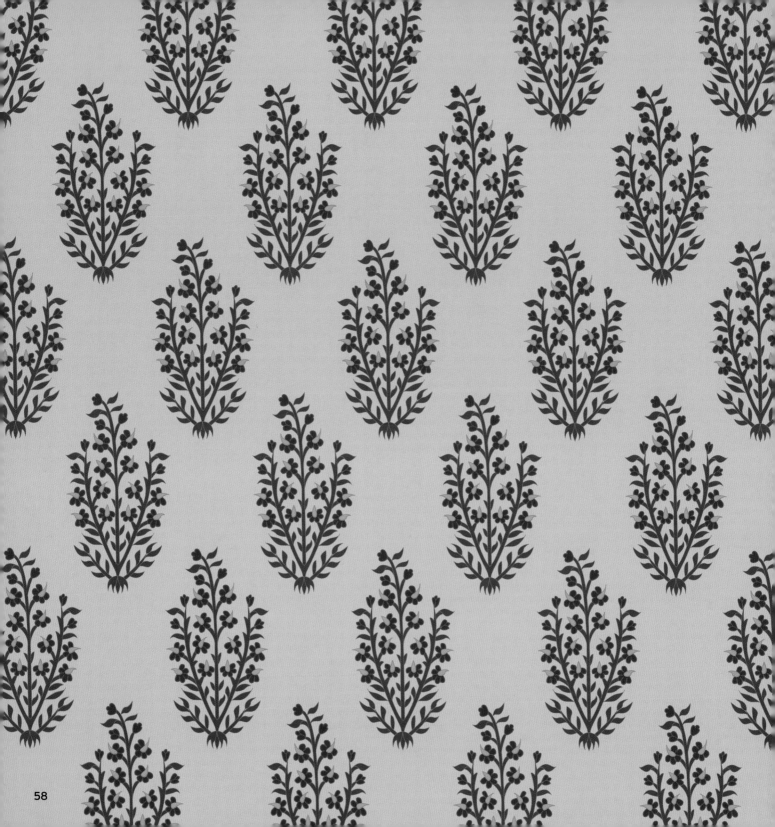

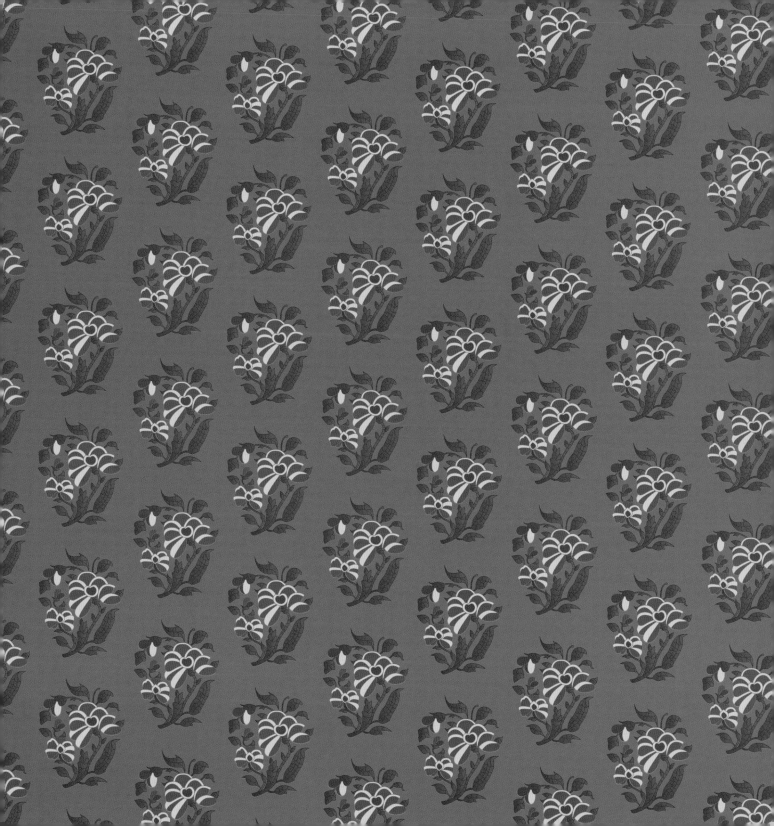

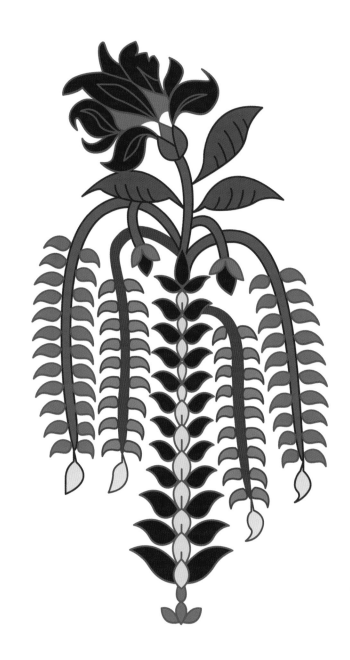

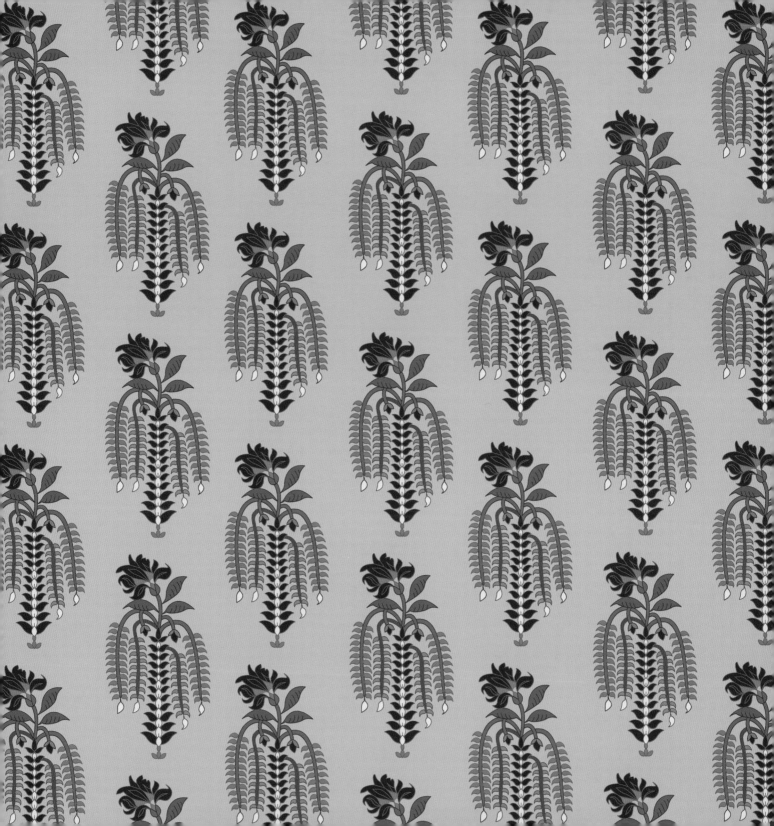

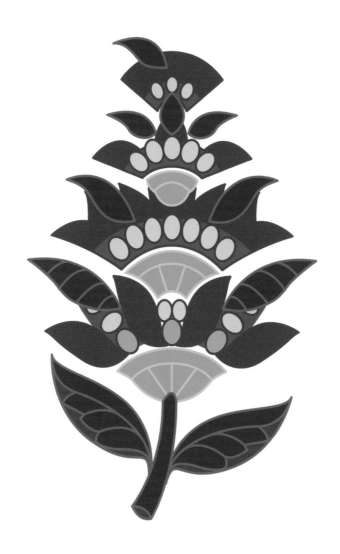

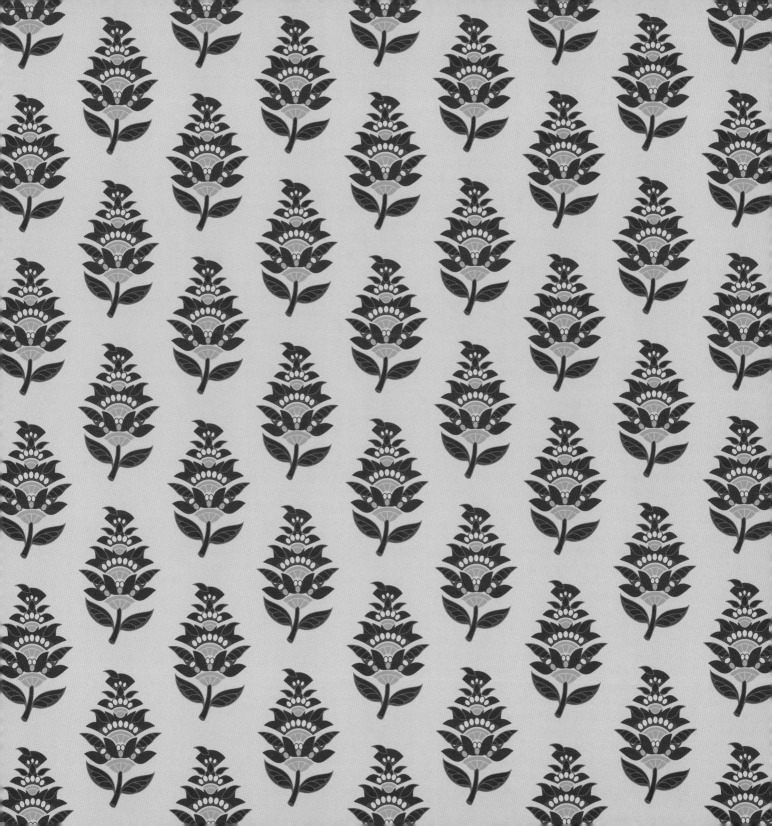

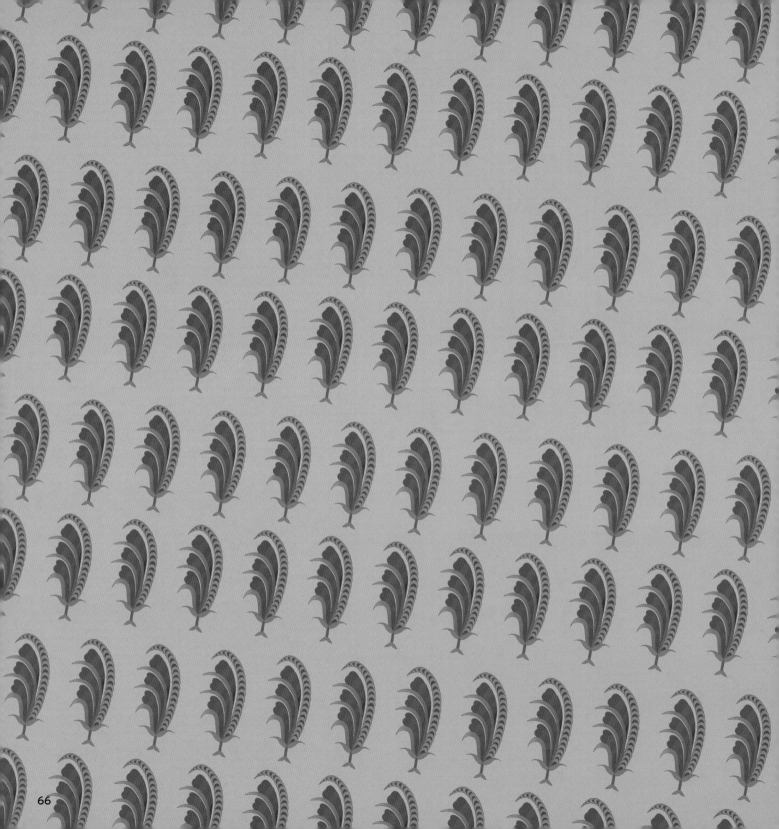

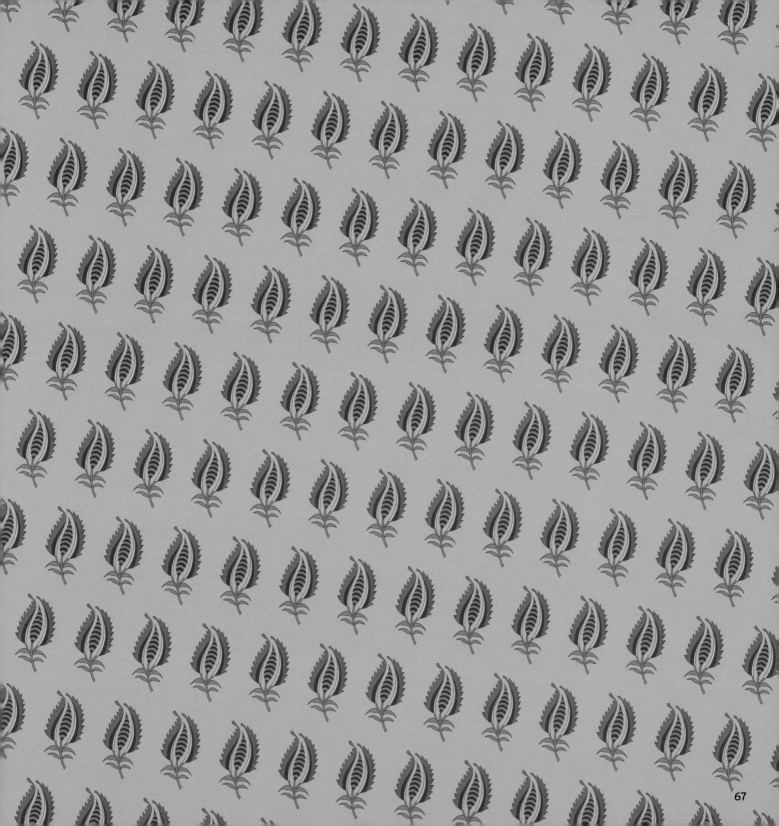

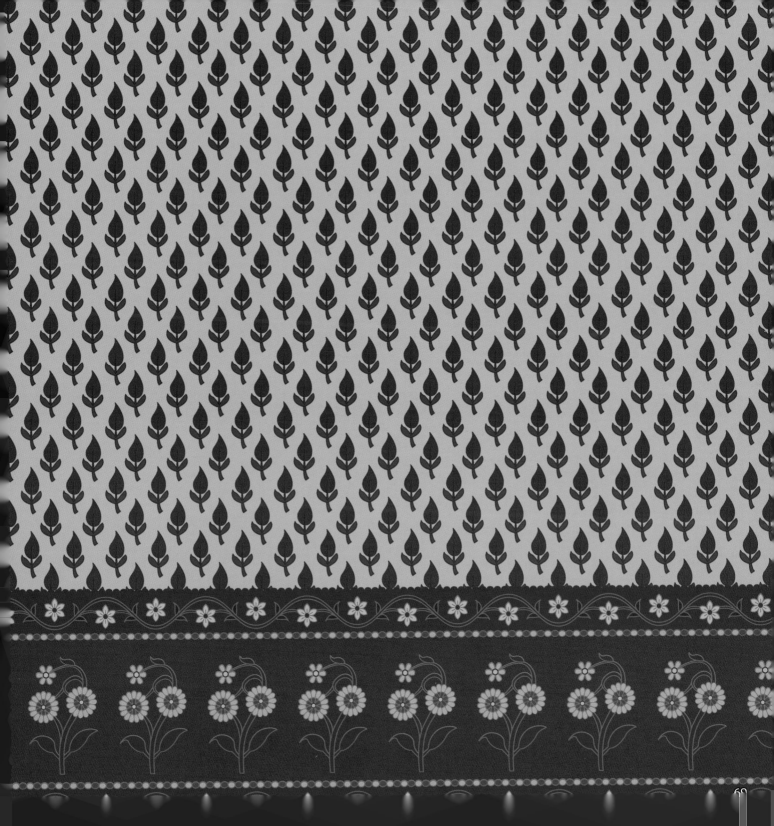

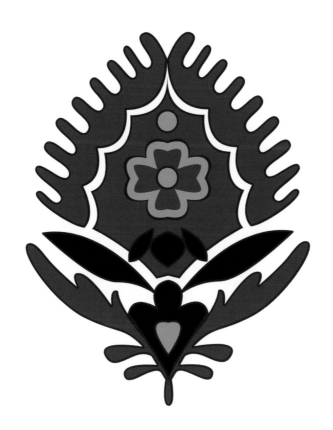

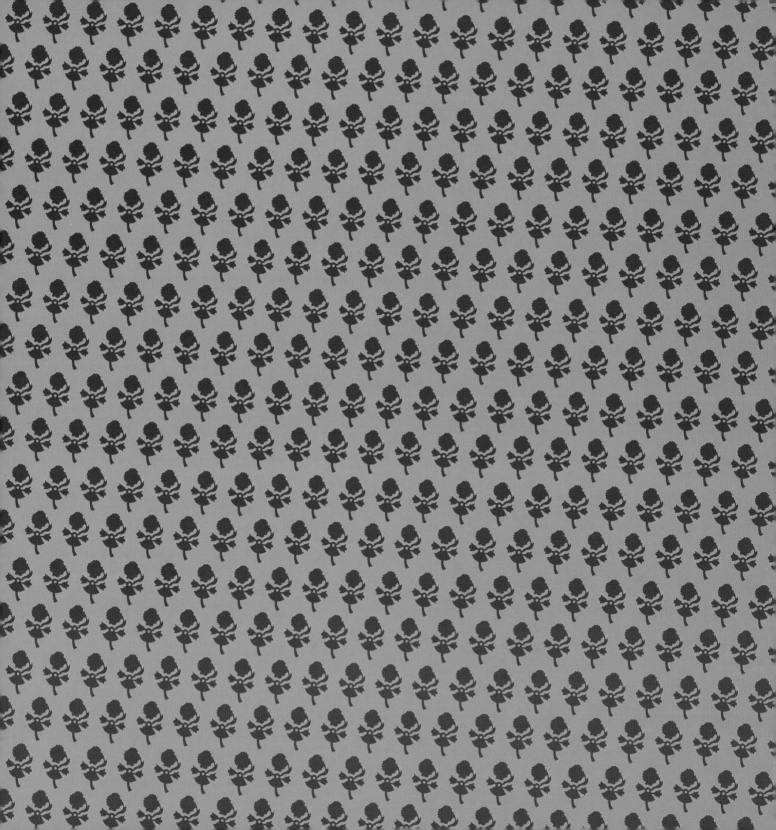

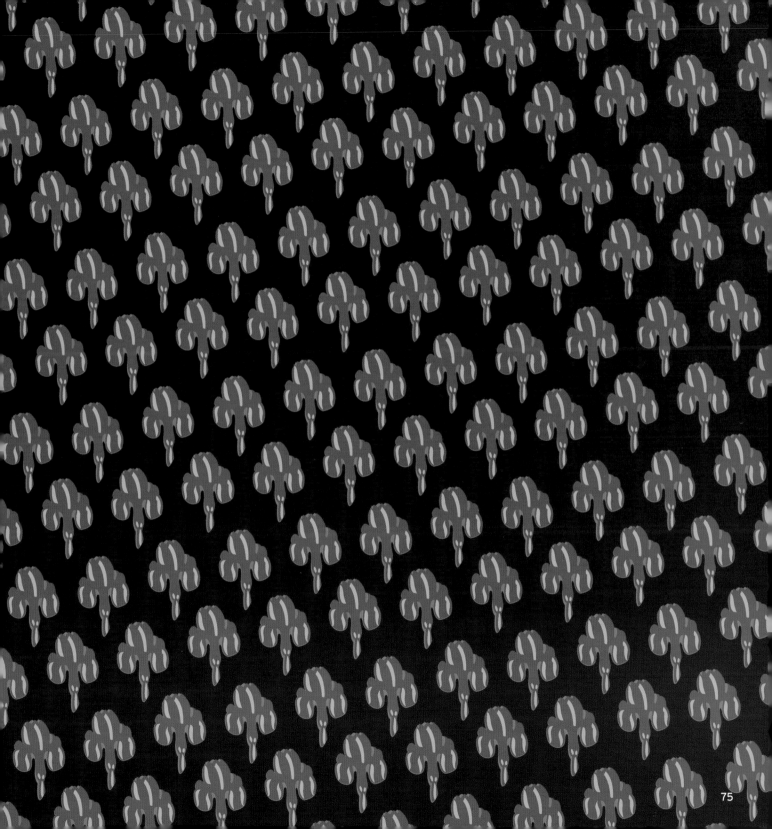

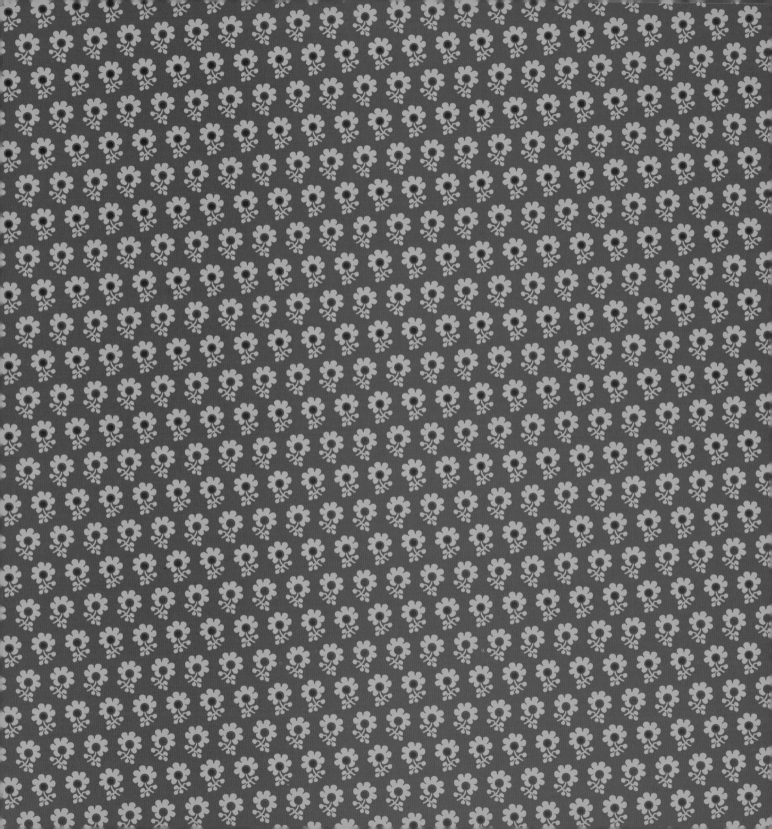

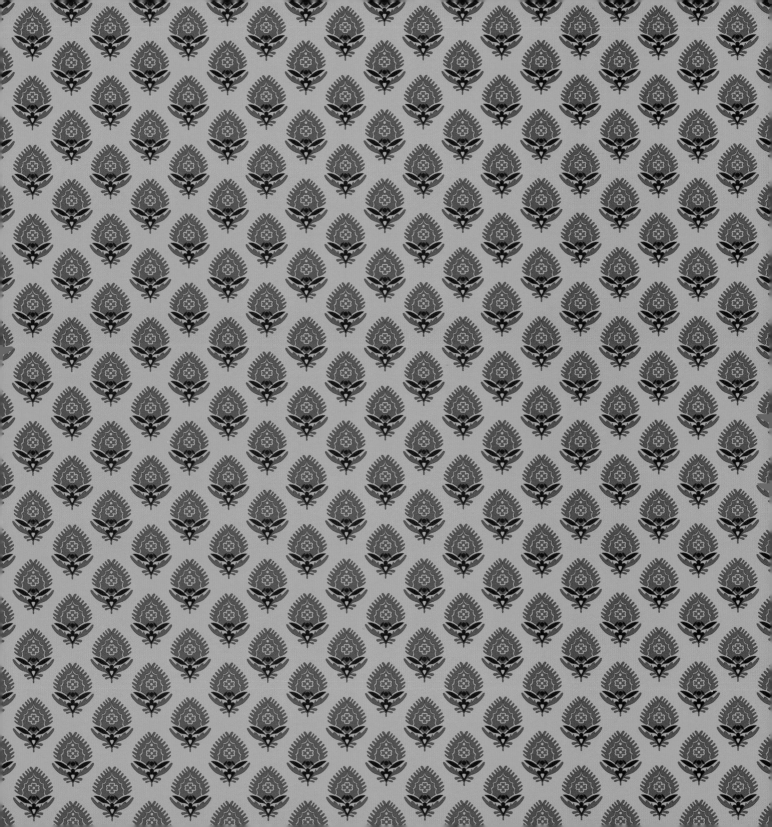

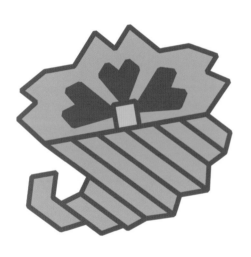

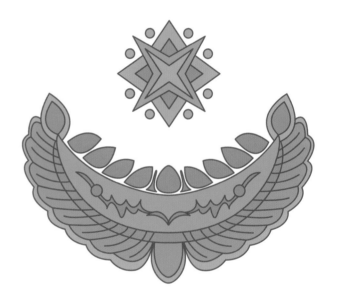

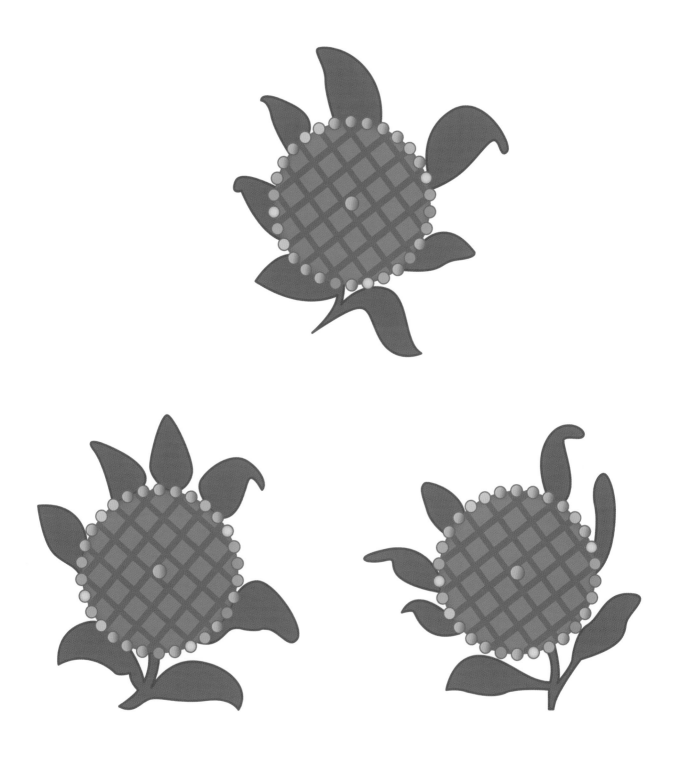

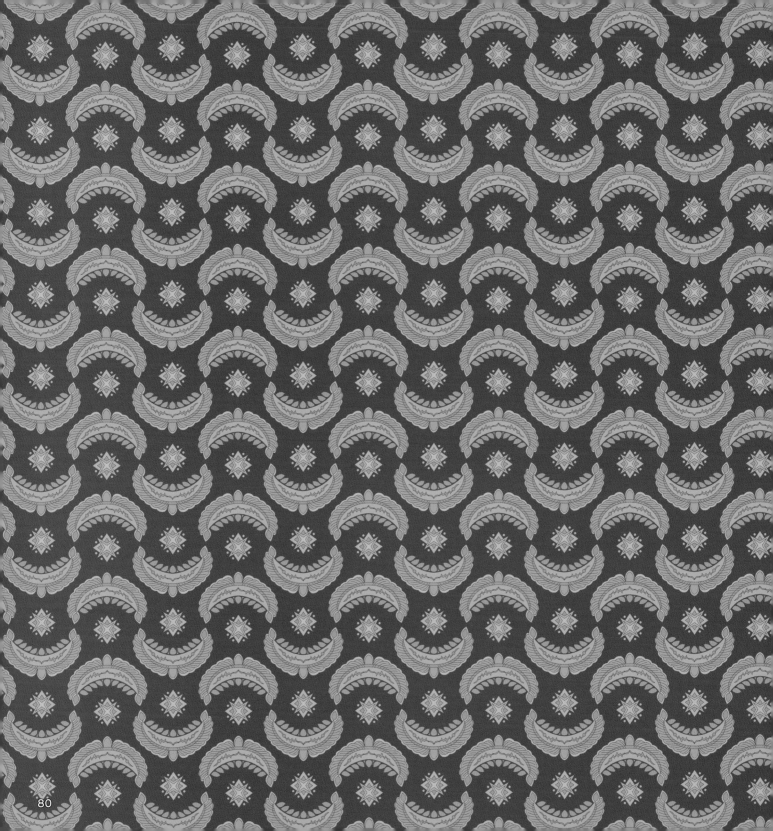

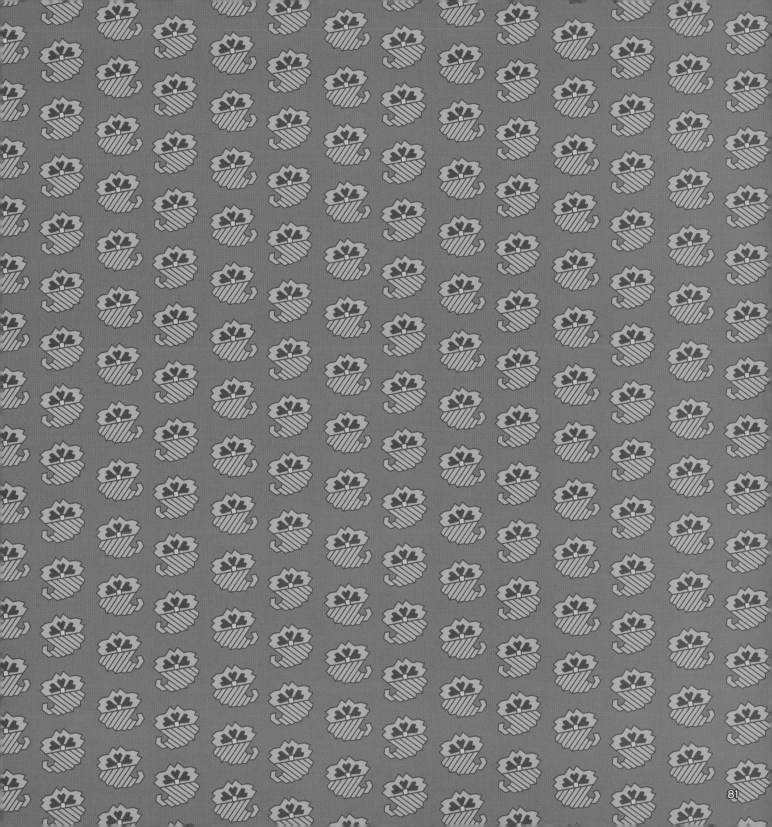

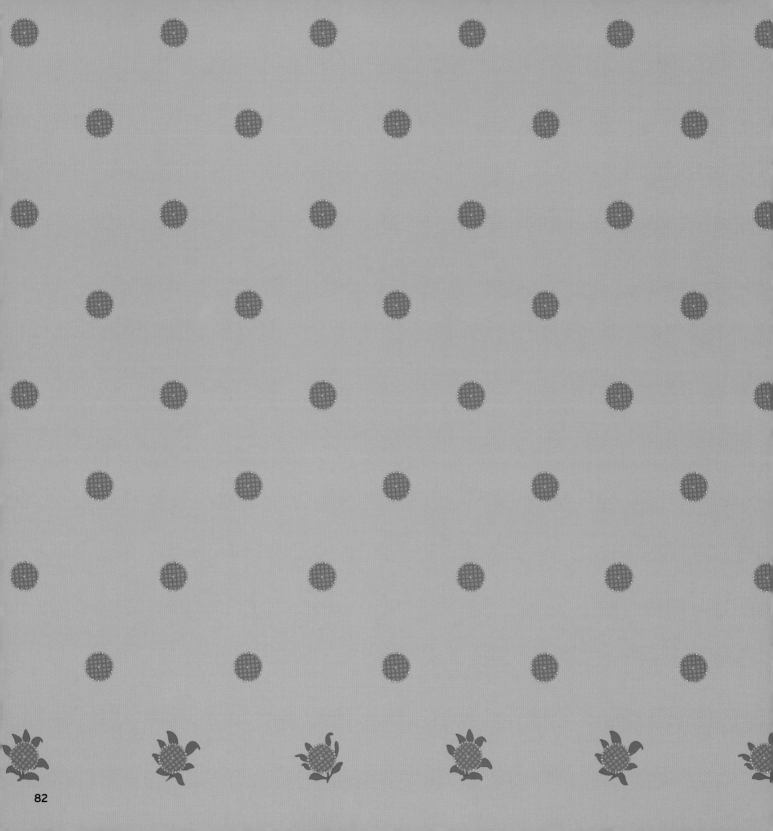

82

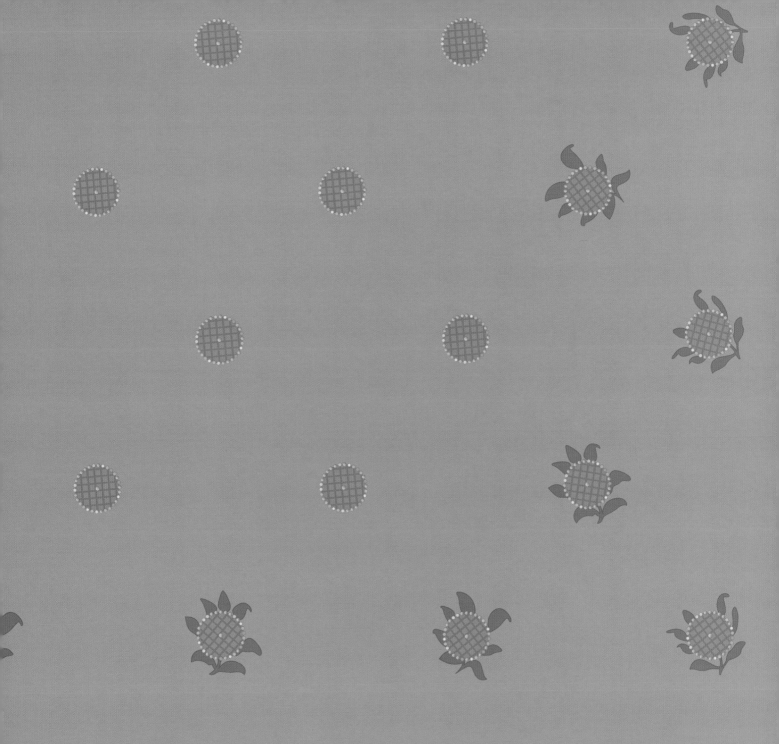

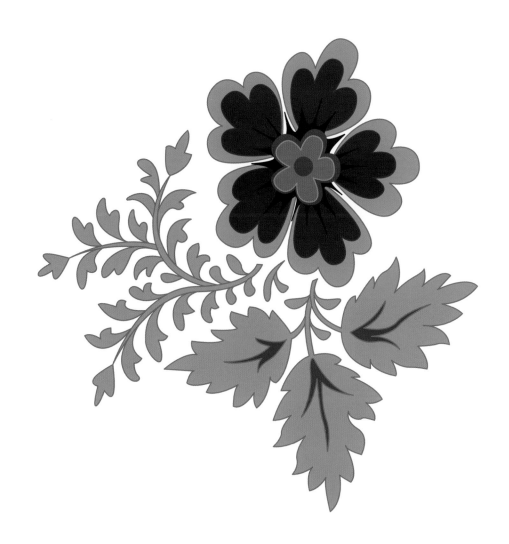

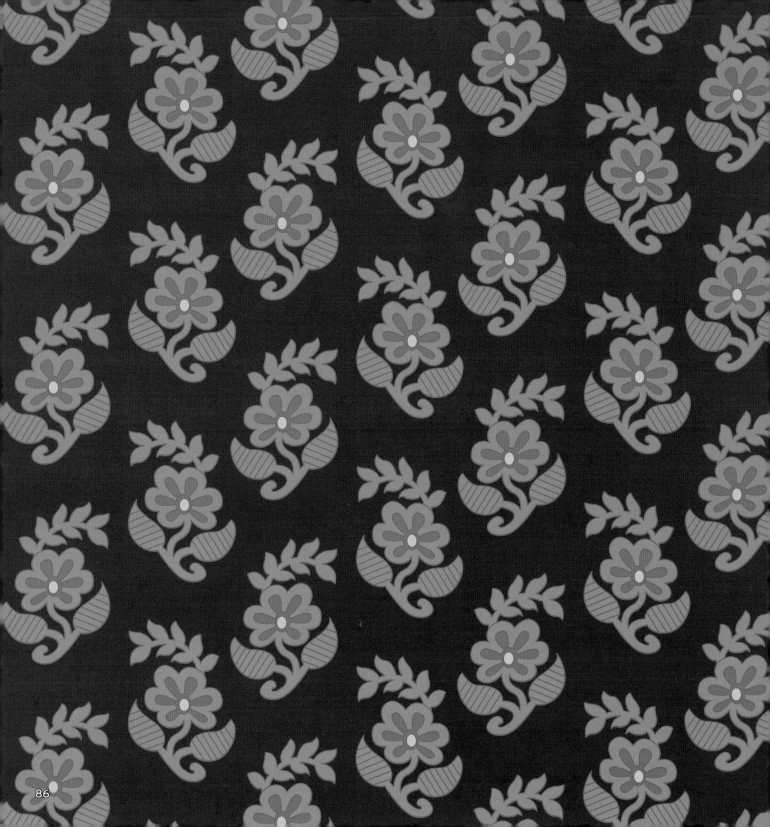

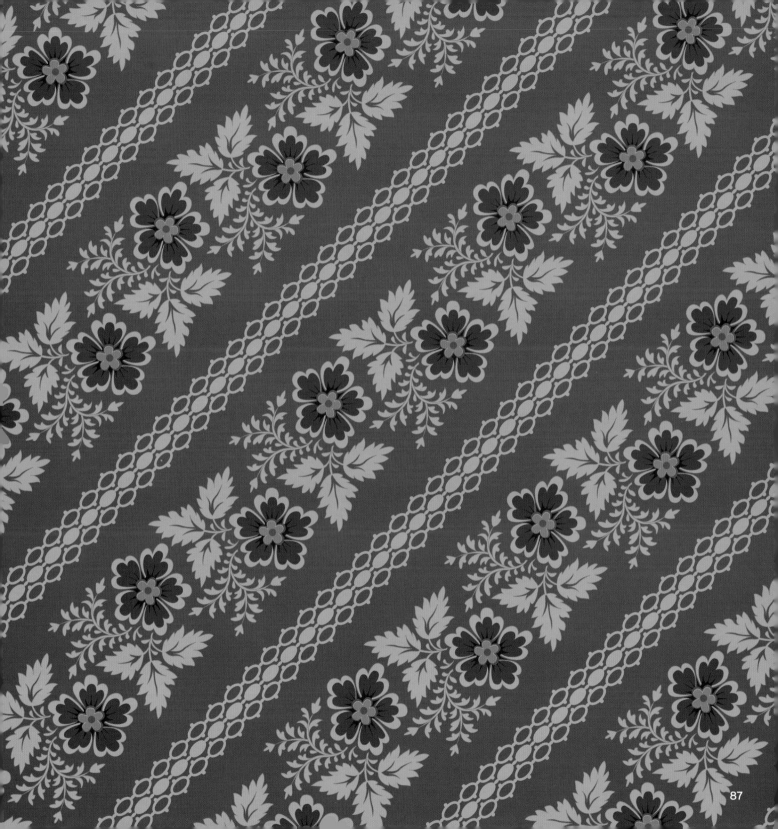

87

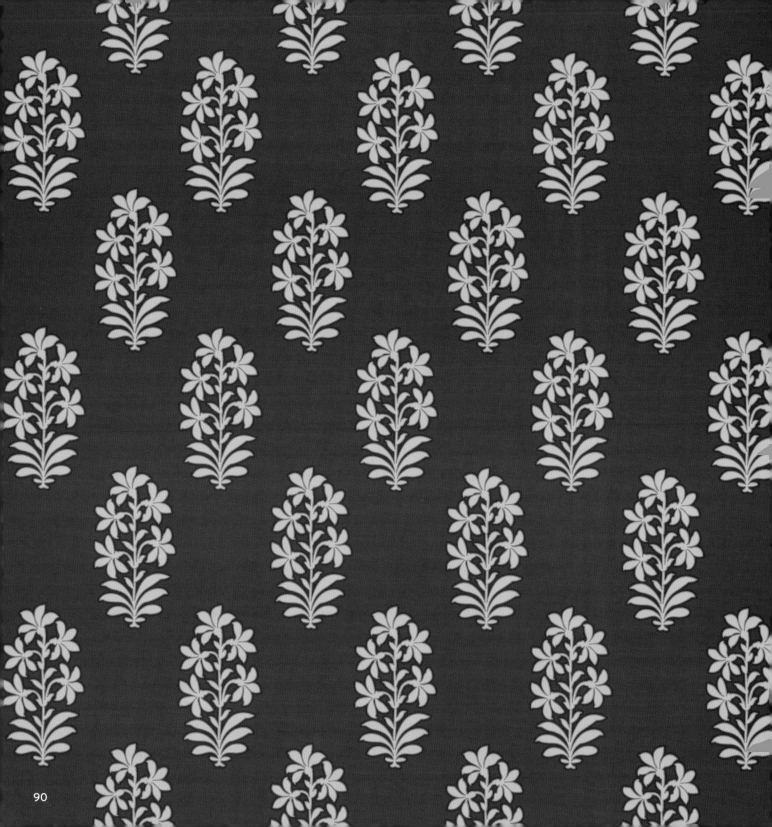

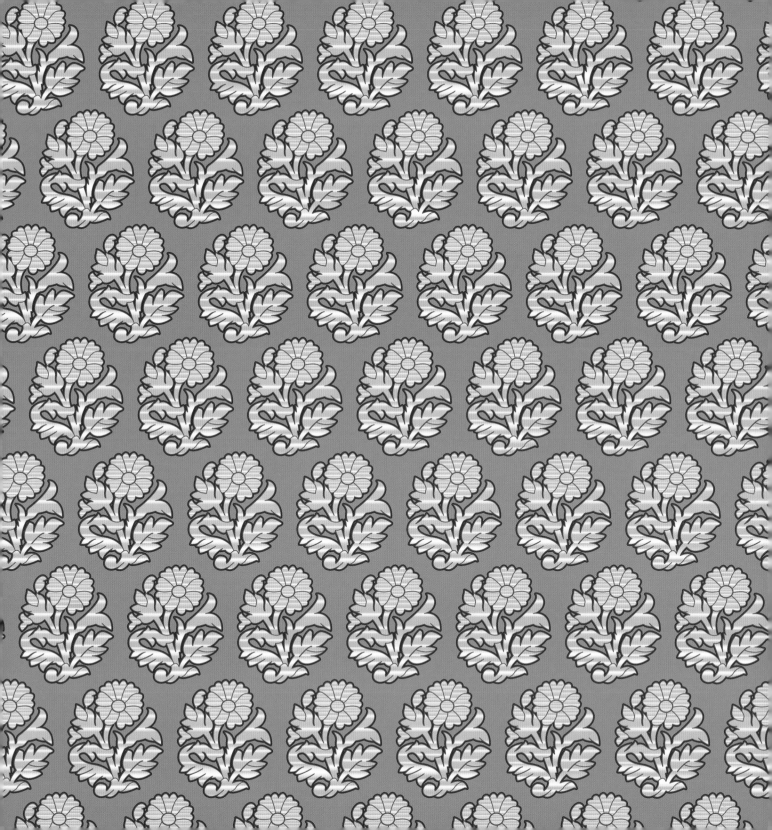

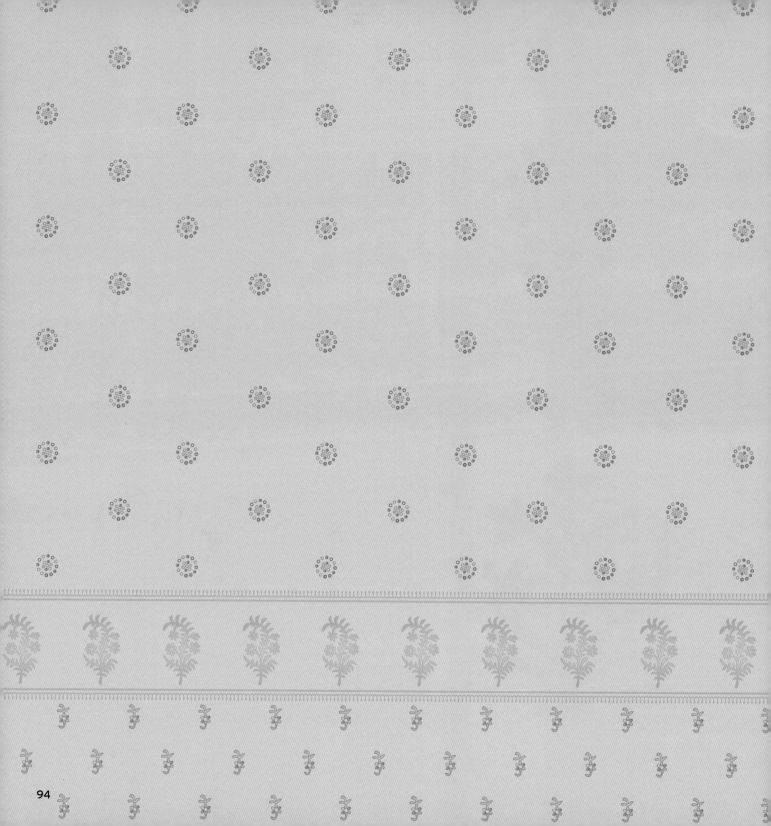

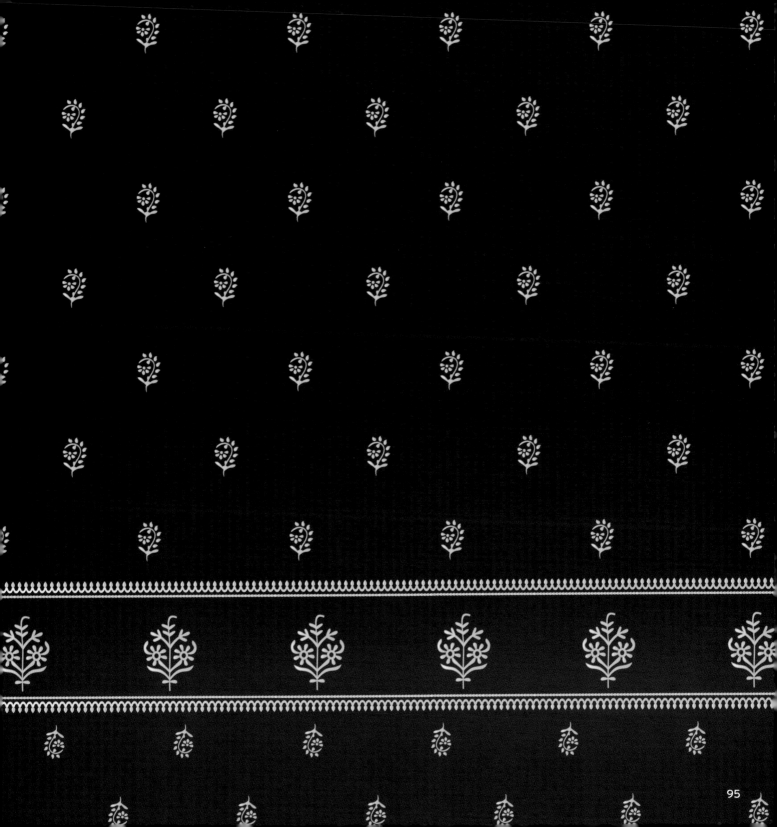

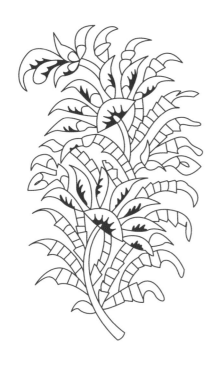

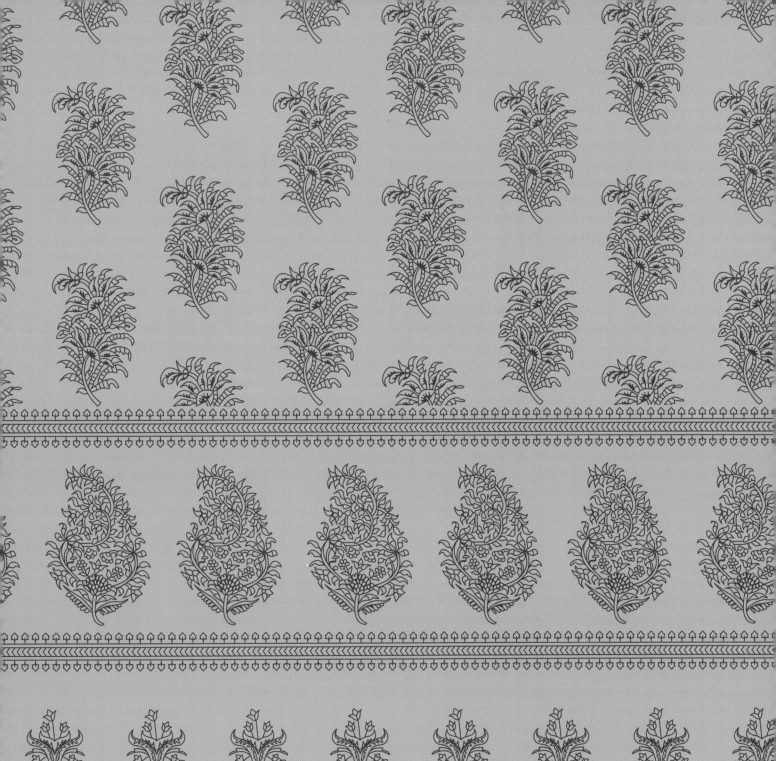

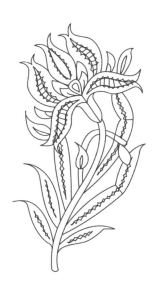

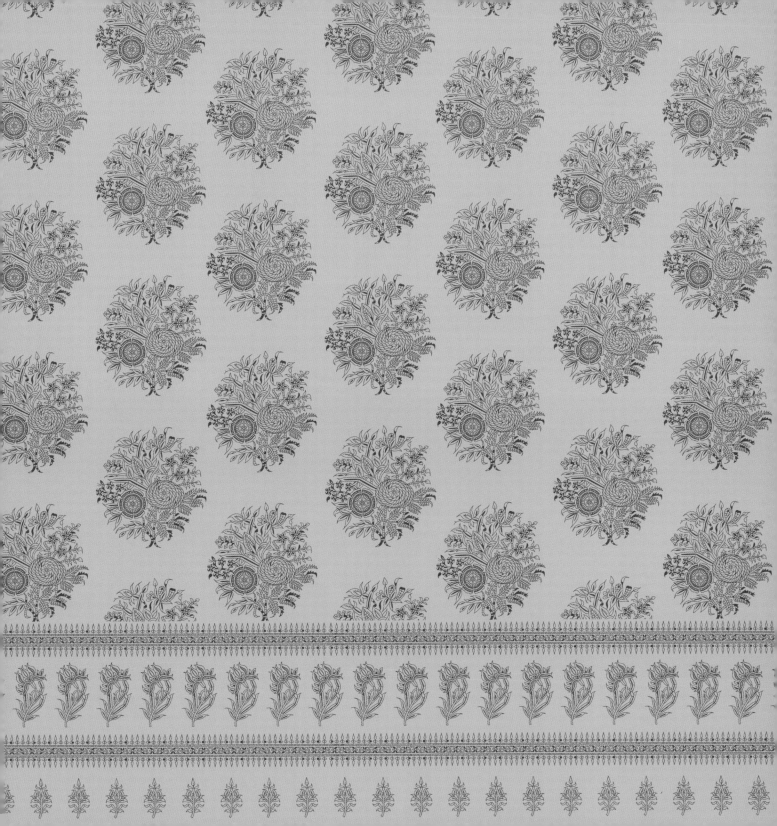

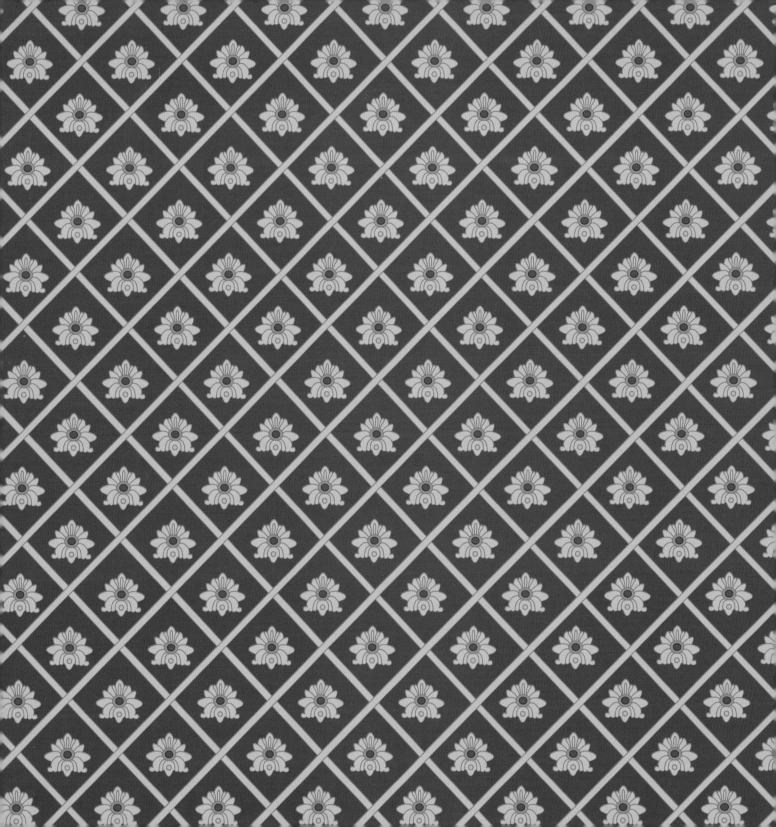

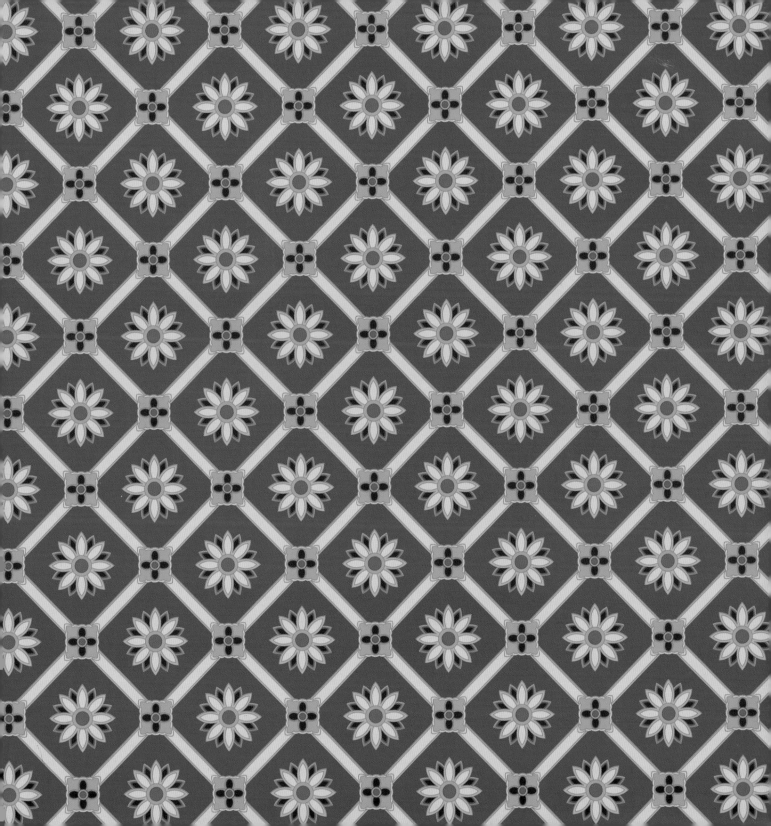

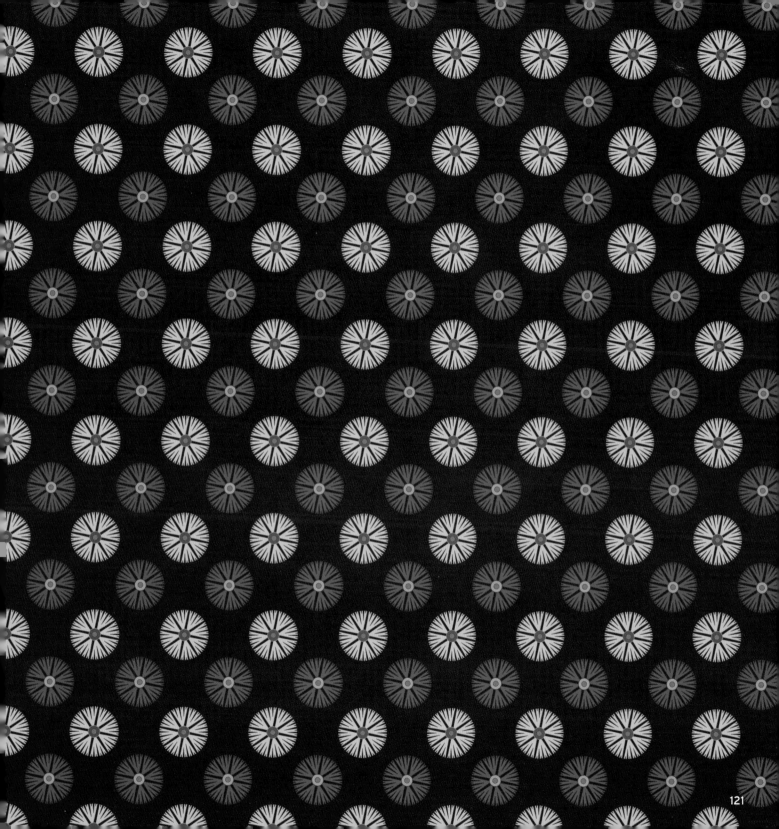

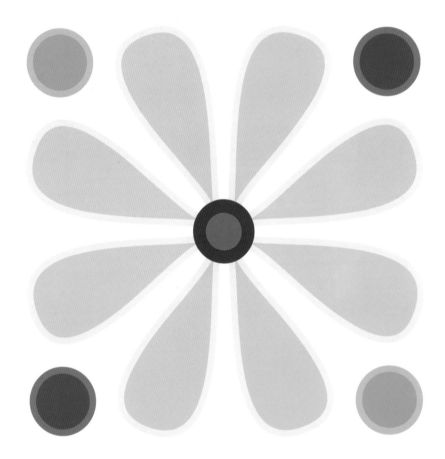

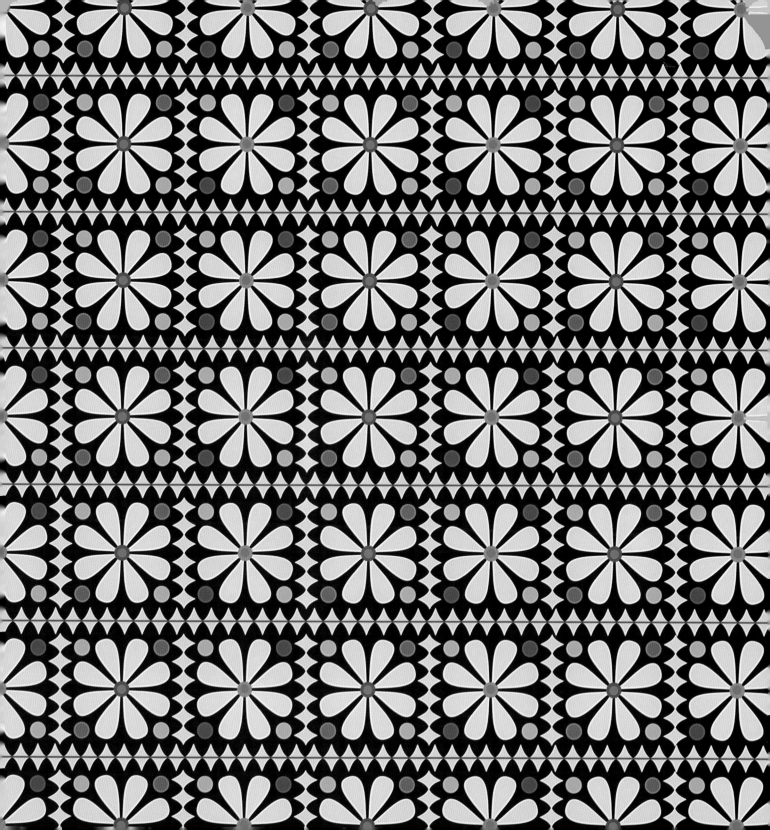

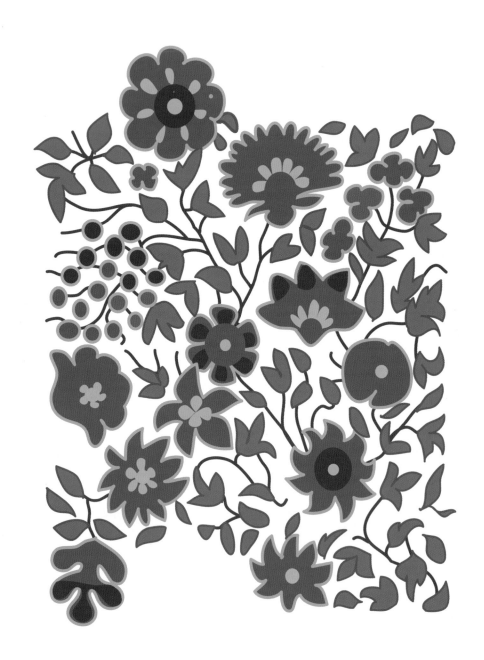

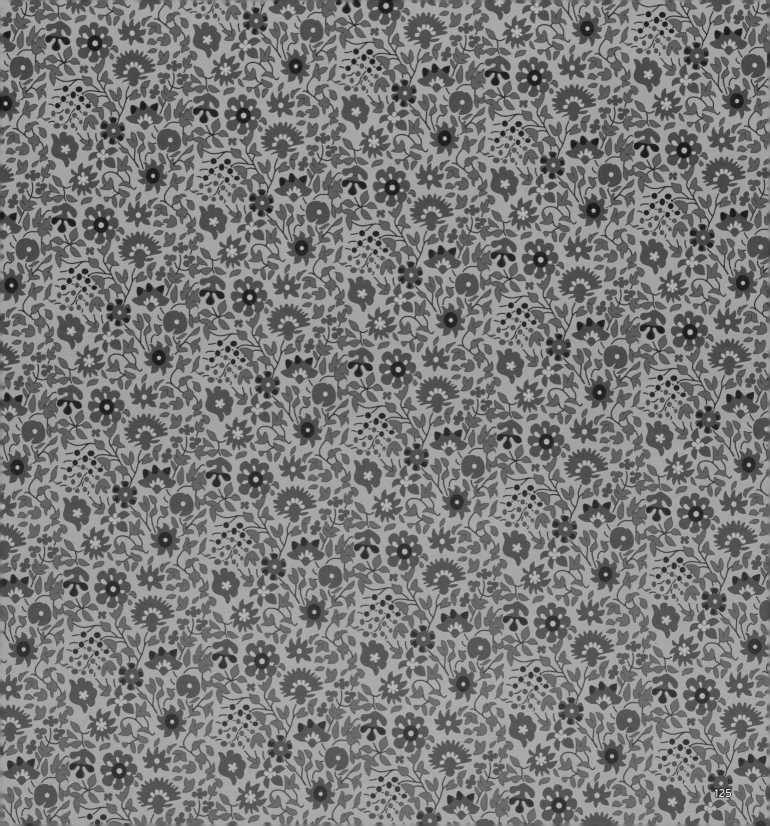

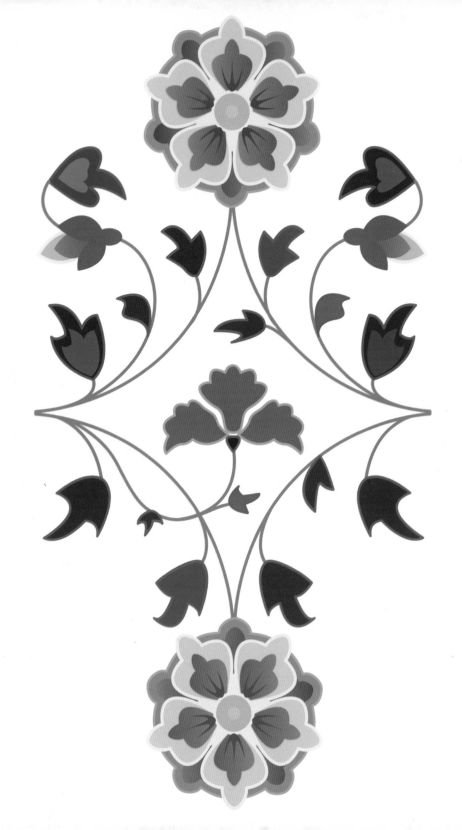

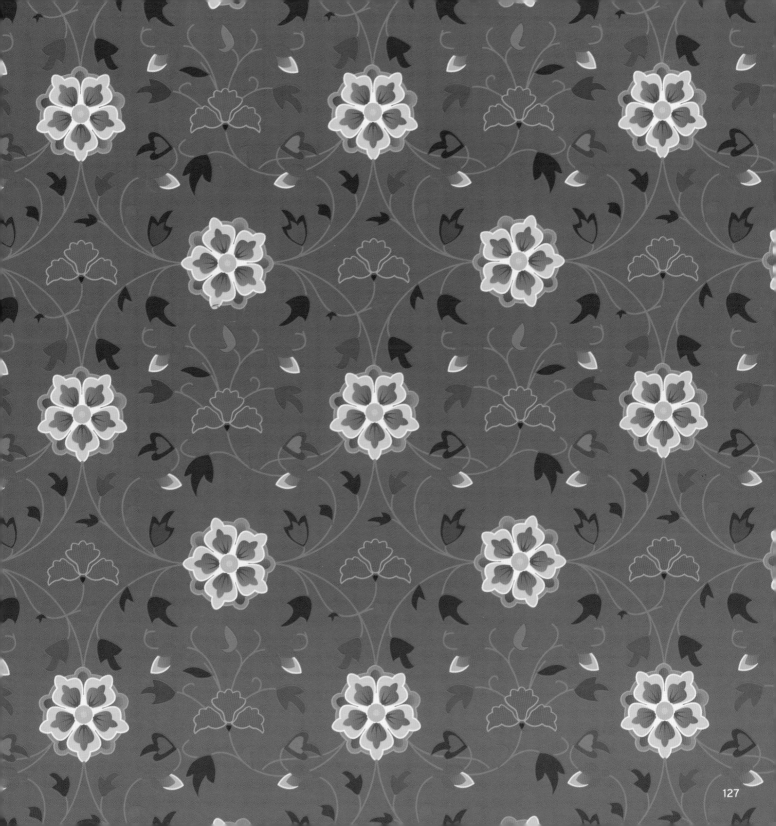

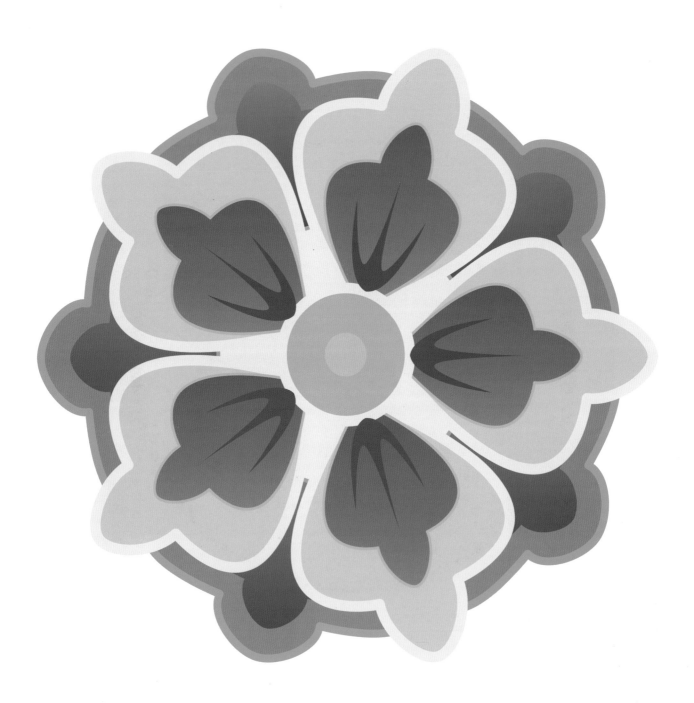